The Land of the Anka Bird

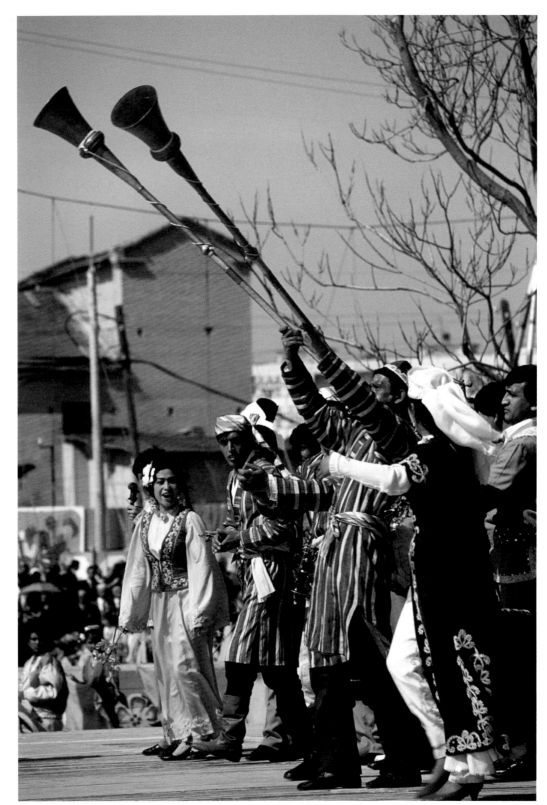

Rites of spring
Uzbekistan

A band of musicians
prepare to perform as
crowds gather to celebrate
the new year. Navruz
festivities take place at the
spring equinox, on March
20 or 21. One man appears
to be playing two long
trumpets, or *karnays*, the
Uzbek national instrument.

A journey through the Turkic heartlands

The Land of the Anka Bird

Photographs by Ergun Çağatay

Introduction and text by Caroline Eden

CORNUCOPIA BOOKS

Ergun Çağatay
1937–2018

Ergun Çağatay began working as a photographer in the former Soviet Union in 1993, after surviving a near-fatal bomb attack in Paris ten years earlier.

Over the following decade he travelled more than 100,000 miles and took more than 40,000 photographs, from Lithuania in the west to Yakutsk in eastern Siberia. These became the basis of *The Turkic Speaking Peoples: 2,000 Years of Art and Culture from Inner Asia to the Balkans* (Prestel, 2006), a book that combined his images with scholarly essays on the history, culture and cuisine of the broader Turkic world.

Çağatay's photographs, mostly unpublished, form a unique archive for anyone wishing to understand the complexities of Central Asia and the vast surrounding region since the Cold War.

Çağatay died in 2018, just as he was embarking on a project to capture the Crimean Tatars, the peoples of the Balkans and the Uyghurs of western China.

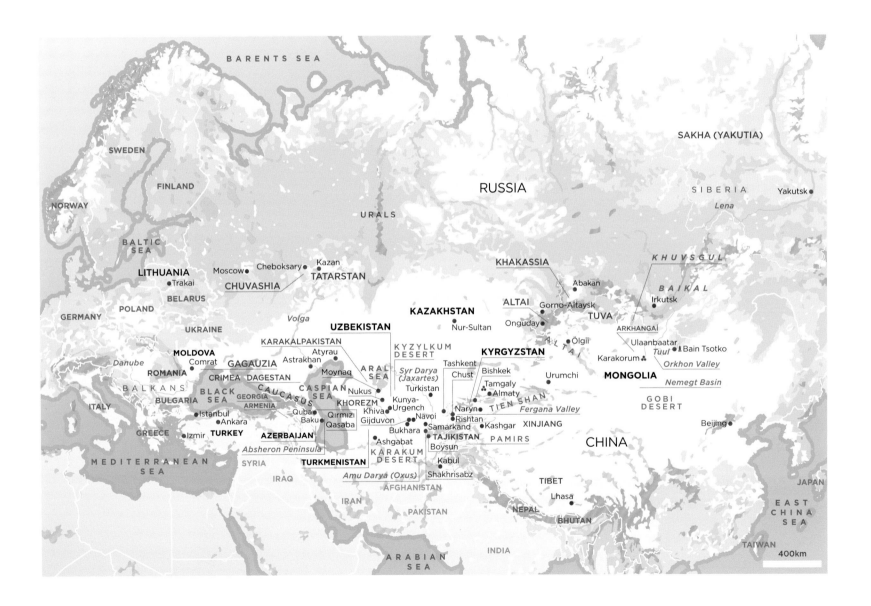

BARENTS SEA

SWEDEN

FINLAND

NORWAY

BALTIC
SEA

RUSSIA

URALS

SAKHA (YAKUTIA)

SIBERIA

Yakutsk

Lena

LITHUANIA
Trakai

Moscow

Cheboksary

Kazan

KHUVSGUL

BELARUS

CHUVASHIA

TATARSTAN

BAIKAL

GERMANY

POLAND

Volga

KAZAKHSTAN

KHAKASSIA

Abakan

Irkutsk

UKRAINE

UZBEKISTAN

Nur-Sultan

ALTAI

Gorno-Altaysk

KARAKALPAKISTAN

KYZYLKUM
DESERT

Onguday

TUVA

ARKHANGAI

MOLDOVA

Atyrau

KYRGYZSTAN

Ölgii

Ulaanbaatar

Bain Tsotko

Comrat

GAGAUZIA

Astrakhan

ARAL
SEA

Syr Darya
(Jaxartes)

Tashkent

Bishkek

Urumchi

Karakorum

Tuul

MONGOLIA

Orkhon Valley

ROMANIA

CRIMEA

Moynaq

DAGESTAN

Chust

ALTAI

Nemegt Basin

BALKANS

BLACK
SEA

CAUCASUS

CASPIAN
SEA

Nukus

Turkistan

Tamgaly

Almaty

BULGARIA

GEORGIA

KHOREZM

Kunya-
Urgench

Khiva

Navoi

Naryn

Rishtan

TIEN SHAN

Fergana Valley

XINJIANG

GOBI
DESERT

Beijing

ITALY

ARMENIA

Quba

Istanbul

Qirmizi

Baku

Ankara

Qasaba

Gijduvon

Bukhara

Samarkand

Kashgar

GREECE

Izmir

TURKEY

AZERBAIJAN

Absheron Peninsula

Ashgabat

Boysun

TAJIKISTAN

PAMIRS

CHINA

MEDITERRANEAN
SEA

SYRIA

TURKMENISTAN

KARAKUM
DESERT

Kabul

Shakhrisabz

TIBET

JAPAN

IRAQ

Amu Darya (Oxus)

AFGHANISTAN

Lhasa

EAST
CHINA
SEA

IRAN

PAKISTAN

NEPAL

BHUTAN

ARABIAN
SEA

INDIA

TAIWAN

400km

The photographs

Why the Anka Bird?

Birds have long been symbols of aspiration and freedom, of colour and song, a link between the earth, the sky and the heavens beyond. But what of the mythological and mysterious Anka Bird? Resembling a phoenix and of enormous size, this fabulous bird was said to live for longer than 1,500 years, to feast on enormous beasts and to dwell in a habitat as obscure as it was puzzling. Home for the Anka Bird was the legendary mountains of Qaf, a region lacking concrete geography but believed to be either the Caucasus Mountains or a series of peaks that belted the earth when it was believed to be flat. Like the mythical Simurgh (Semrük in Turkic languages), the Anka Bird was celebrated in poetry as a symbol of the strength of life and love.

Uzbekistan, the heartland of Central Asia, has the Homâ Bird. Although it is the national Uzbek emblem, it is not as famed as the Anka or the Simurgh. In *The Language of the Birds*, an epic poem by the 15th-century Chagatai-Turkic bard Alisher Nava'i, the Homâ is a secondary character, featuring more within folklore and fairytales, where it has the ability to throw its shadow onto the one destined to become king.

These mythical birds can also be symbols of fortune. In Uzbekistan there is a saying, '*boshiga Xumo qushi qo'nibdi*', which translates as 'the Homâ bird landed on his or her head', meaning that a person is blessed with good fortune.

The legendary Anka Bird, or Zümrüd-ü Anka in Turkish, was chosen for the title of this book of photographs by Ergun Çağatay as it symbolises the spirit that reaches across the Eurasian continent to link the richly diverse cultures of the Turkic peoples.

Peoples of the Turkic heartlands

Stretching in an arc from the Balkans to inner Asia, and encompassing at least 140 million souls, the Turkic-speaking world is as far-reaching as it is wildly varied. Dwelling on the edge of the Karakum (Black Sands) desert in Turkmenistan are the Turkmen, many retaining nomadic traditions, living lives of pilgrimage and offering the visitor sincere hospitality. With the exception of Tajikistan – whose language, Tajik, is related to Dari and Farsi – the other Central Asian republics, Uzbekistan, Kyrgyzstan, Kazakhstan, all speak a Turkic language.

Westwards from Central Asia are the Gagauz, Moldova's Turkic Christians, and northwest, into Lithuania, are the Karaim, members of the Turkic Kipchak group, who have practised Judaism on the shores of the Baltic Sea since the 14th century. In the far northeast of Russia live the 'Siberian Turks', the Yakuts, an ancient people who hunt, fish and herd deer in a vast, frigid land. Elsewhere, Russia hosts an eclectic group of Turkic speakers, from the Volga Tatars, mainly in Tatarstan, to the Altaians in western Siberia, from the Chuvash in the centre of European Russia to the Khakas of Khakassia and the Tuva Turks, both inhabitants of southern Siberia.

Far more unites than divides these people, with many sharing art and culture, religion and even body language. While most Turkic speakers are Sunni Muslim, there are Lamaist-Buddhists in Tuva, an autonomous Russian republic bordering Mongolia, shamanists among the Yakuts of northeast Siberia, and Christians in Khakassia, another Russian republic. In northern Azerbaijan, a Turkic-speaking country that historically saw waves of Oghuz and Seljuk Turks, lives one of the most remote Jewish communities in the world, hidden in the shadows of the impenetrable Caucasus Mountains on the border with Russia's Dagestan.

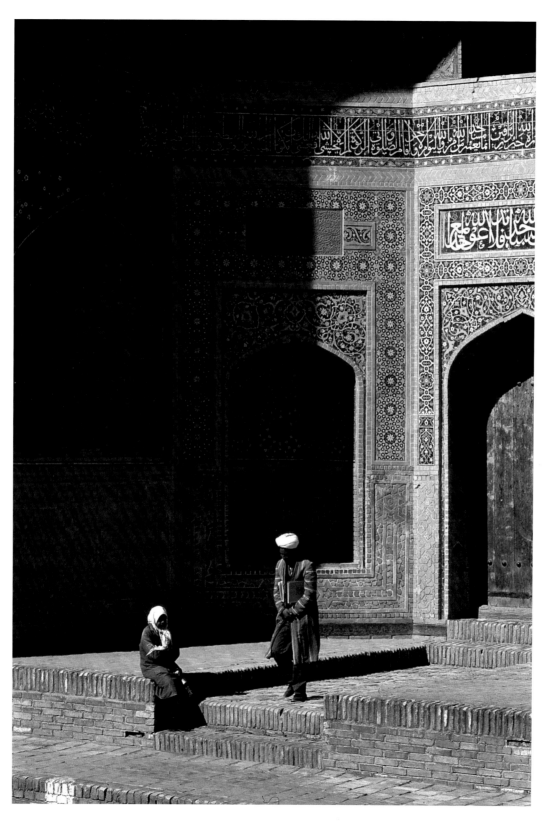

Portal of
the Great Mosque
of Bukhara
Uzbekistan

A cleric makes his way
out of Bukhara's Kalyan,
or Great, Mosque. Above
the arch behind him is
a stone plaque with an
interesting inscription: a
rare survivor, it is a royal
decree of 948H (1542) in
which Sultan Abdulaziz
Bahadur of Bukhara
grants his subjects
sizeable sums of *tanga*
and 18,000 bundles of
fabric, one for each family.

Completed in 1514, the
Kalyan Mosque is a fine
example of the carved
alabaster and polychrome
tilework that decorate
Timurid buildings
throughout Central Asia.
Dazzling calligraphy
often features, too, as
in the cursive scroll-like
Thuluth script seen
in the tiles here.

introduction Caroline Eden

A freight train loaded with crude oil traverses the vast, dun-coloured steppe of Kazakhstan. In Uzbekistan, a dusk-lit trading dome softly glows in the last light. Out on the Central Asian lowlands, springtime poppies create a boundless carpet of blazing red. Extending far beyond the scope of normal sight, these are rare images caught in the frame of the Turkish photographer Ergun Çağatay's camera. Each is stamped with a distinctly warm gaze, for Çağatay, born in Izmir, did not find himself a stranger in the vast Turkic-speaking world.

Like all good chroniclers, Çağatay harboured a natural skill for celebrating people and places, and in his photography he both reveals and conceals until, curiosity piqued, we either surrender and lose ourselves entirely in the image, or else we desire to know more: what lies beyond that hazy mountain range? What lives are lived inside that yurt? And what are those men in that shady waterside *chaikhana* (teahouse) discussing so intently?

In turning the pages of this book, an optical arcadia of the Turkic-speaking world is revealed. But it is an accurate and honest portrait, too, casting light on a web of diverse Turkic groups and cultures, from the Balkans to Siberia. Linked linguistically, there are many shared cultural elements to be found here: in art and architecture and in carpets and caravans. In hammams, horse riders and hats. And in clothes: warm furs in winter, folding fans in summer.

In bringing these lands to us, Çağatay removes our gaze from modern Turkey – and the much-surveyed historic world of the Ottoman Empire – and takes us elsewhere. Together we go into Central Asia (the five Central Asian republics, the 'Stans'), Mongolia, the South Caucasus, Russia and eastern Europe, travelling through layers of time and distance, observing the wilderness, where a yak herd moves at twilight and an eagle hunter rides out on horseback, and to cities where a chef cooks *plov* (rice pilaf) and townspeople in northern Azerbaijan walk through the snow. We learn of the Karaim of Lithuania, the smallest group of Turkic-speaking people, once in charge of guarding the storybook castles of the Grand Duke Vytautas, who took Turkish tribes to his homeland in the 14th century. We also meet the Gagauz, celebrating Easter at an Orthodox church in Moldova, and the Turkic Yakuts of northeast Siberia, who expertly weather winter lows of –56°C and take part in shamanistic rituals wearing sparkling amulets. The connections that these diverse groups share highlight the enormous mobility of Turkic-speaking peoples over different centuries and landscapes.

It took a crisis, and the fall of the Soviet Union, for Çağatay's obsessional project – a photographic survey of an intimidatingly huge region, the entire Turkic-speaking world – to come to fruition.

On July 15, 1983, Çağatay stood at the Turkish Airlines ticket counter at Paris Orly Airport, waiting to fly home to celebrate his wife's birthday. As he queued, a home-made bomb, placed in cabin baggage by the Secret Army for the Liberation of Armenia, exploded, killing eight people and wounding dozens. Çağatay's own injuries, severe burns, meant it would be five years before his hands were able to operate a camera again. But as a long-term patient in the burns unit of a military hospital just outside Paris, he had his Nikon F2 with him at all times. And it was there that an ambitious plan began to form, born of a deep desire to bear witness to, and visually record, the Turkic-speaking world. The resulting book, *The Turkic Speaking Peoples: 1500 Years of Art and Culture from Inner Asia to the Balkans*, was published by Prestel in 2006. It is epic in the truest sense of the word.

A journalist-photographer, Çağatay was used to hard assignments and hard news. He was there at the Olympic Games in Munich in 1972, and in the immediate years afterwards he was capturing election rallies in Anatolia. In 1979, he assisted the Magnum photographer Gilles Peress to get his film out of Iran during the hostage crisis in Tehran. Then, in the 1980s, eclectic assignments saw him documenting intriguing world events, from the political manoeuvring of Ayatollah Khomeini to young Turks busily building new lives in Berlin after the Wall came down. Whatever he photographed, his images always had immediate

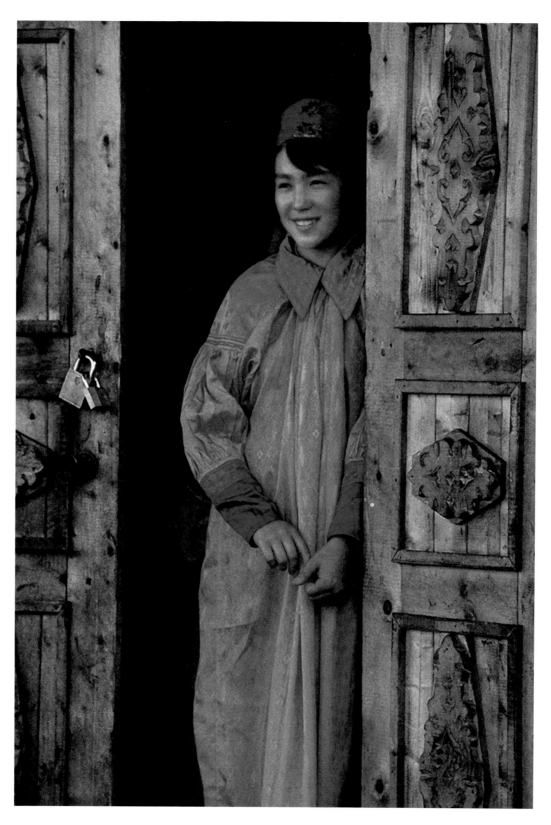

A warm Siberian smile
Abakan
Khakassia, Russia

A girl stands smiling
in the carved doorway
of a village house near
Abakan, capital of
Khakassia in southern
Siberia. Living among
steppes, mountains,
lakes and caverns, the
Khakas (Hakas in Turkish)
have protected their rich
culture, which dates back
thousands of years. Often
Christians, they speak a
Turkic language similar to
Uyghur, and also adhere
to shamanistic beliefs.
Woodcarving on doors
is found throughout the
Turkic-speaking world,
especially in Uzbekistan.

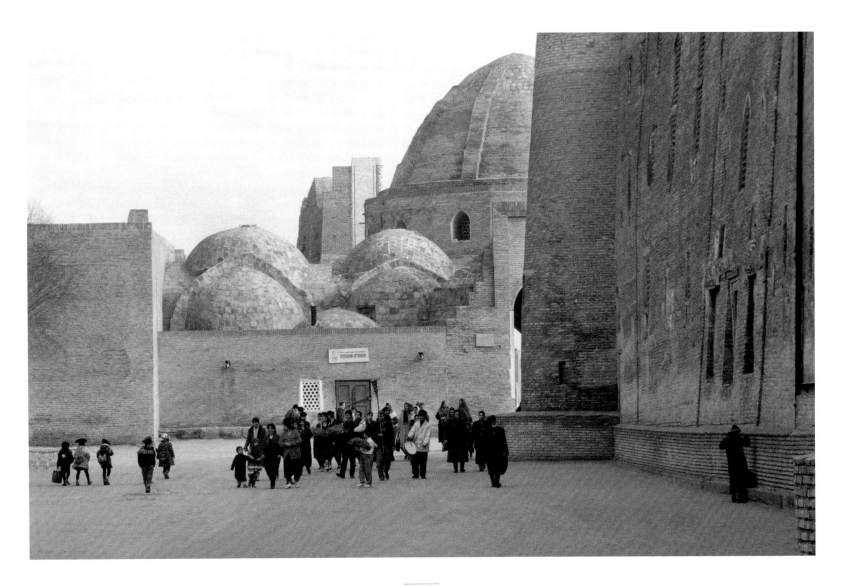

impact. But perhaps with such impulses there was a danger of repetition, and so after the fall of the Soviet Union in 1991, which made obtaining the necessary papers possible, he set off to photograph the Turkic-speaking world – a vast and complex region where 'the earth is hard, the heavens far', as the Central Asian saying goes.

It is not only the clear-eyed visual histories within these images that make them so successful: it is because, in viewing the photographs, we become onlookers, too, travelling through space and time with Çağatay until we can smell the mud, musk and melons and the incense smoke of churches, and feel the extreme continental temperatures in our bones and on our skin.

One of the most dramatic photographs included here is of abandoned trawlers in Moynaq, a town in the Karakalpak region of northwest Uzbekistan. A former fishing port, it once employed more than 30,000 people. Stranded in the desert scrubland, the boats are instantly recognisable as a symbol of the Aral Sea disaster. Çağatay goes further, not only showing the eroded vessels banked on the sand where the sea once was – before it was drained dry by the irrigation of cotton fields – but accentuating the tragedy by photographing one boat with a gang of children leaning over the bow. Six young lives likely never to see what the Aral Sea once was, nor to work on it as their forefathers did.

In the early 1990s, while travelling in Central Asia, Çağatay compiled a historic collection of photographs of the region for his touring exhibition *Once Upon a Time in Central Asia* (which went to Japan, the USA and Sweden). An abbreviated version of a two-hour documentary called *Aral* that Çağatay produced won first prize at the Antalya Film Festival in 2000.

The world lost this outstanding photographer in February 2018. Çağatay had plans for a second volume of *Turkic Speaking Peoples* that would have included Crimean Tatars, the peoples of the Balkans and the Uyghurs. The mission, and hope, of *The Land of the Anka Bird* is to bring Çağatay's vivid world – documenting both the nomadic and settled and the social and political – to those who may not know him yet. To revive and reintroduce his work to a new generation and to share a small slice of an archive that is as magical as it is phenomenal. And, in doing so, to remember and honour him.

We enter a vanished space and a vanished time. Çağatay was a witness to both history and change. Take the clothes worn by male tea drinkers at the poolside *chaikhana* in Bukhara; the turbans, *telpaks* and quilted coats are rarely worn by the younger generation except at festival time, and dozens of *chaikhanas* built for contemplation have fallen victim in the name of modernisation. Çağatay's photographs are a reflection of cultures that will probably not be there in a decade or two.

Edinburgh, 2020

Opposite
**Bukhara's
domed bazaars
Uzbekistan**

A wedding party carrying colourful parcels and musical instruments strolls in front of the Tâqi Zargarân, the goldsmiths' bazaar built in 1586–87 in Bukhara, the historic centre of the Silk Road. Today this cavernous mud-brick 'trading dome' is full of carpets, fur hats, Tsarist-era knives, Soviet tea boxes, samovars, bolts of ikat silk, embroidered scarves and spices, as well as jewellery.

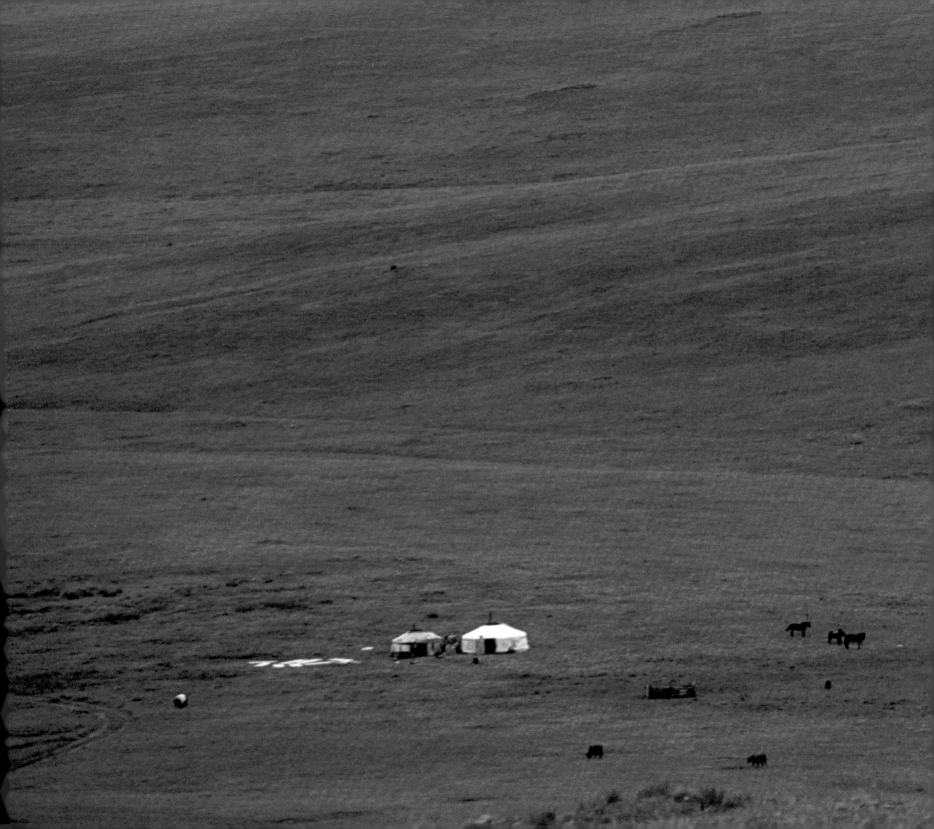

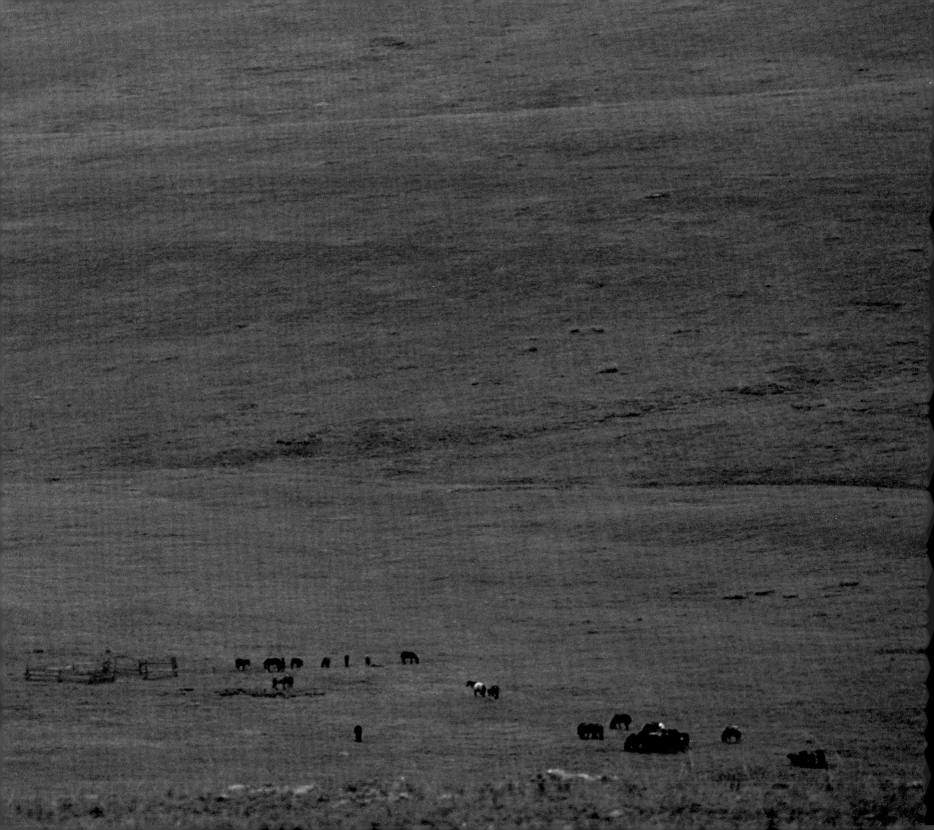

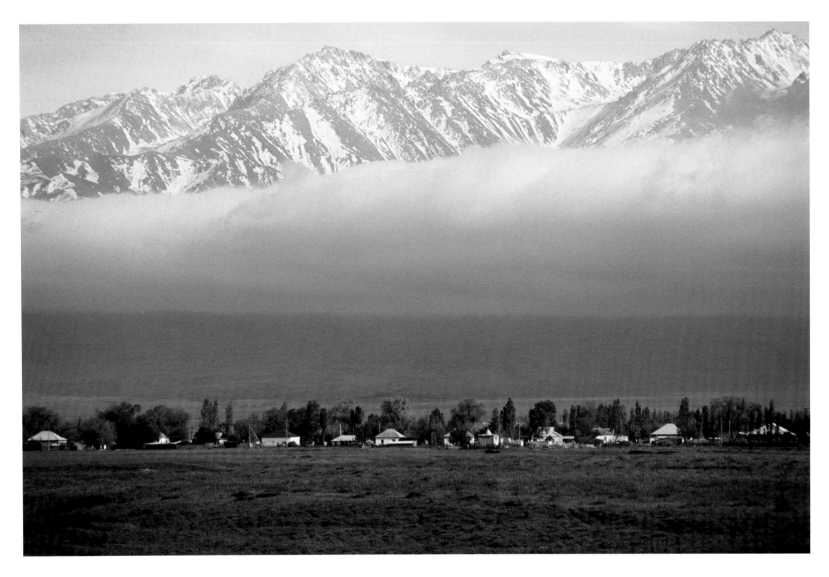

Nomad encampment
Mongolia

Two solitary yurts stand out in a carpet of lush green. For nomadic families, tents (or *gers*, as Mongolians call them) and animals are life's essentials. Clan chiefs once counted their kinsmen by the columns of smoke rising from yurts. Part of nomadic life across the Asian steppe for millennia and as mobile as its inhabitants, this willow-frame tent can be erected and dismantled in minutes, carried on a camel or yak and assembled elsewhere. Made of thick felt, it is warm in winter, cool in summer and ideal for following the fresh grazing.

The yurt goes by several names. Turkic in origin, meaning home, the word may have entered English from the Russian '*yurta*' but is rarely used by anyone who lives in one. The Mongolian *ger* means literally 'house'; in the Turkic languages it is an *oi*, *oüy* or *üy* (hence *ev*, the Turkish for house). In Kazakh it is a *kiyiz üy*, literally 'felt house', in Kyrgyz *boz-üy*, 'grey house', from the colour of the felt.

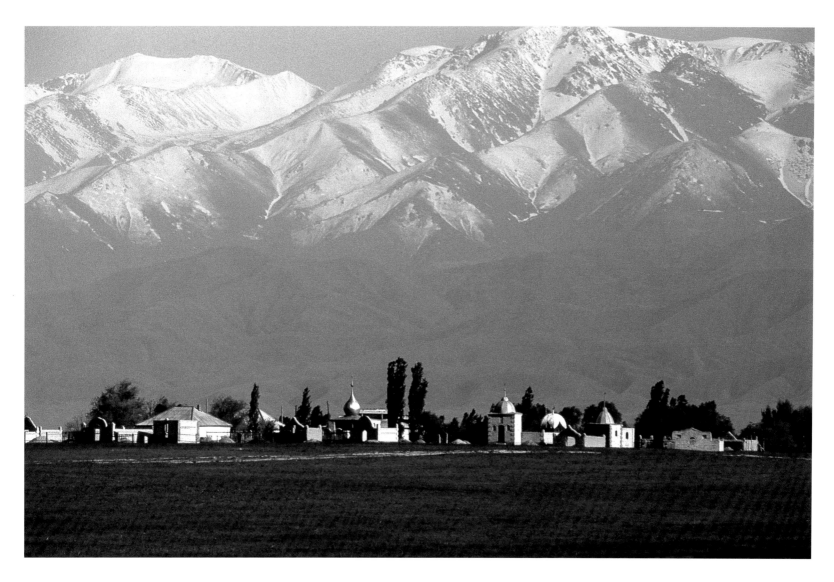

Heavenly peaks
Kazakhstan

A cemetery dotted with domes (above) in a leafy Kazakh village (opposite) on a plain below the snow-capped Tien Shan, or Celestial Mountains.

The range is known in the Turkic world as Tengri Tagh, or Tanrı Dağları – *tanrı* being the Turkish word for God. Tengrism was the religion of the early Turkic rulers and of Genghis Khan's Mongol Empire.

The entire mountain chain stretches for 2,500 kilometres, as far as Xinjiang in northwest China. At the heart of the Central Tien Shan, close to the Xinjiang-Kyrgyz border, is Khan Tengri (7,010 metres), the range's snowy citadel, a postcard-perfect pyramid peak with sharp symmetrical ridges.

The range forms a natural border between today's Kazakhstan and Kyrgyzstan, but borders have meant little to nomadic people. Kazakhs and Kyrgyz, for instance, can still be found in large numbers as far afield as Afghanistan, China and Mongolia.

Almaty, the former capital of Kazakhstan, has as its backdrop the northernmost range of the Tien Shan, which makes it one of the most handsome cities in Central Asia.

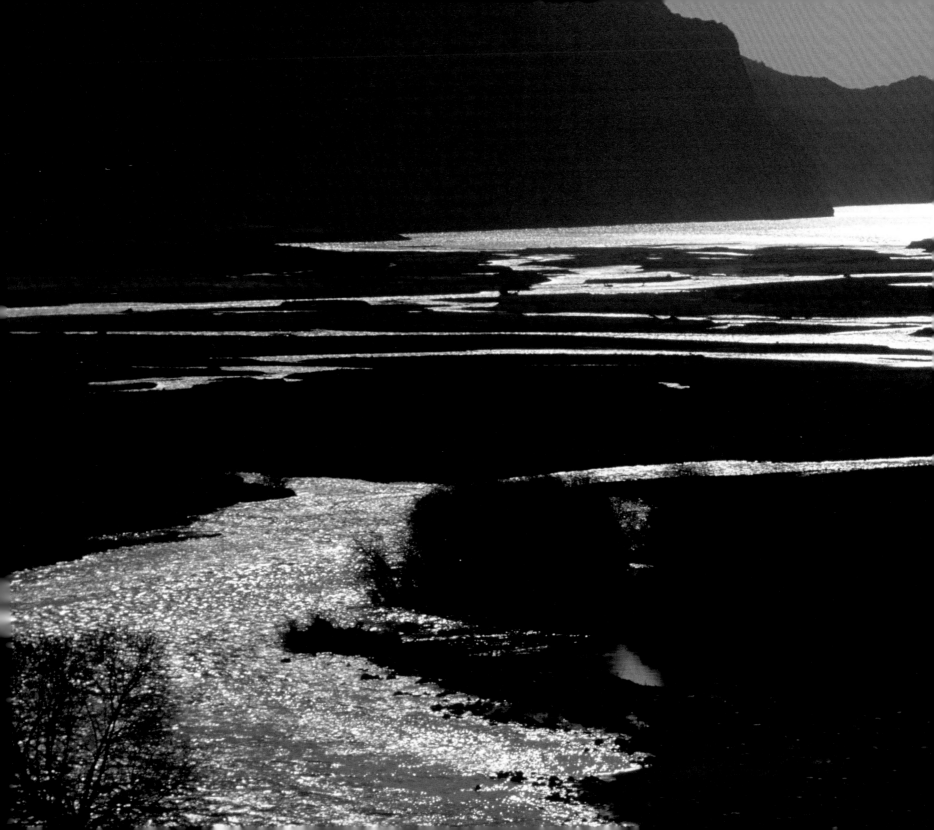

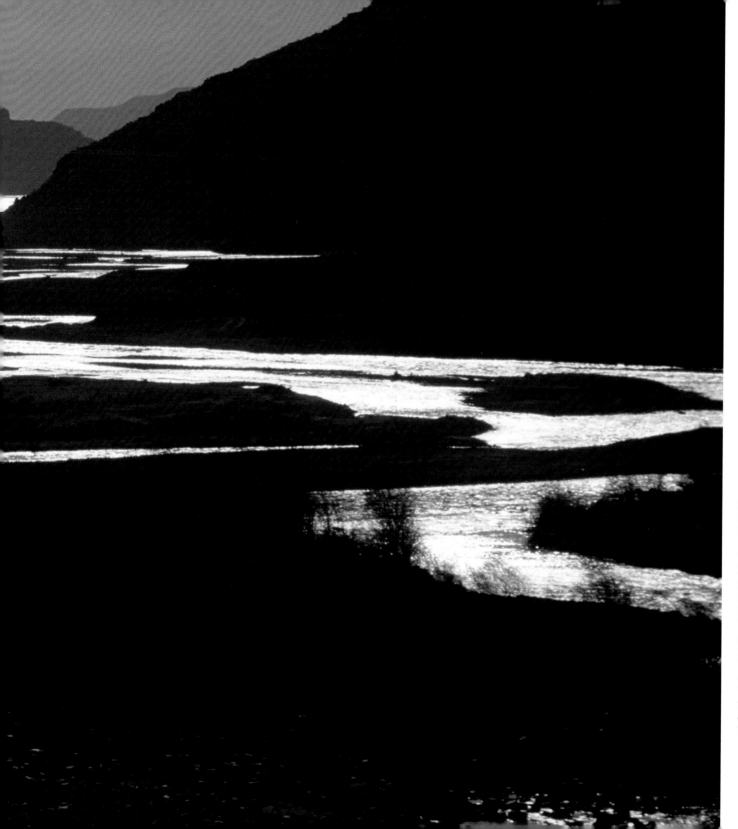

Lifeblood of
the heartlands
Uzbekistan

The two major rivers of
Central Asia are the
Syr Darya (Jaxartes) and
the Amu Darya (Oxus).
Flowing from the mighty
Tien Shan, the Syr Darya
once marked the
northern extremities of
Transoxiana and the edge
of the nomadic steppe.
The Amu Darya, spilling
from the high Pamirs,
divided the Persian and
Turkic worlds.

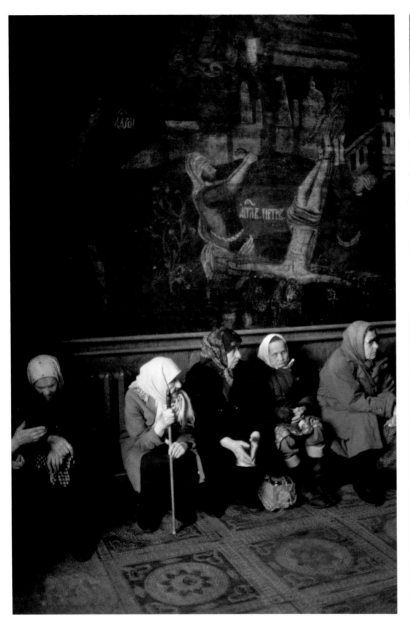

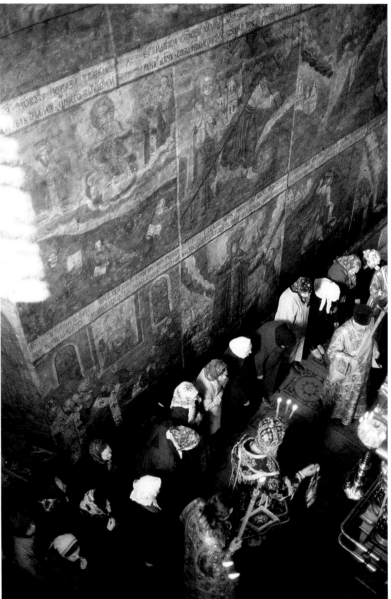

Orthodox ritual
Cheboksary
Chuvashia, Russia

Easter in the 17th-century Vedensky Cathedral: elderly women wait below a fresco of the martyrdom of St Peter as the Chuvash Metropolitan makes his entrance in sumptuous vestments. Candles, incense and the glow of gold in the darkness create a ritual sense of awe.

Cheboksary is the capital of Chuvashia, a republic in the centre of European Russia. The Chuvash speak a form of archaic Turkic and are probably descendants of the Volga Bulgars. They gradually converted to Orthodox Christianity after the Khanate of Kazan fell to Ivan the Terrible in 1552 and their land became part of the Russian Empire.

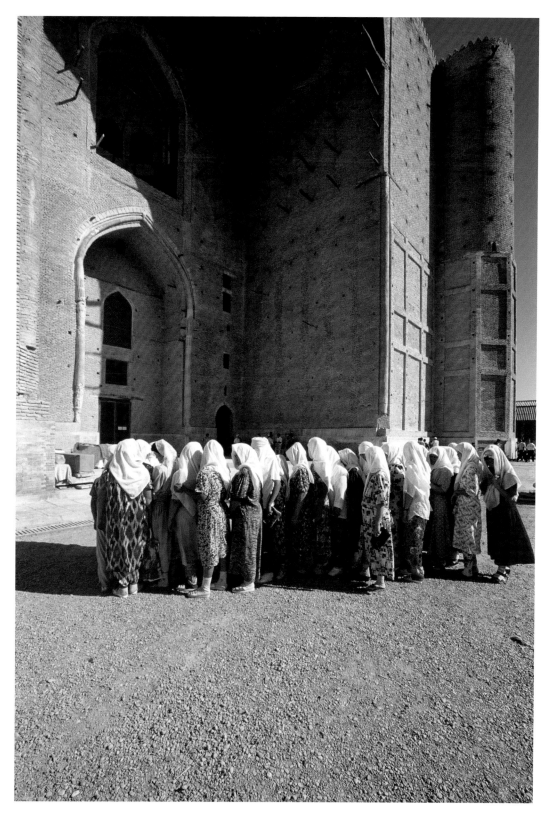

Homage to a Sufi saint
Turkistan
Kazakhstan

Women in the Kazakh town of Turkistan line up to visit one of the holiest sites in Central Asia, the grave of the Sufi mystic Ahmed Yesevî, whose sacred poems, collected in *Divan-ı Hikmet* (*Book of Wisdom*), are a landmark of Turkish literature.

Timur (Tamerlane) ordered this massive edifice to commemorate the Sufi saint two-and-a-half centuries after his death in 1166. Although the shrine was left unfinished when the conqueror died in 1405, it became the inspiration for far-reaching Timurid architecture.

Founder of one of the most widely followed Sufi orders, Ahmed Yesevî turned the town into one of Central Asia's greatest centres of learning. His melding of shamanism and Islamic mysticism helped to define Islam in the Turkic lands. So holy is the site (named in his honour Hazret-i Turkistan, 'The Blessed One of Turkestan') that three pilgrimages to it are said to equal one to Mecca.

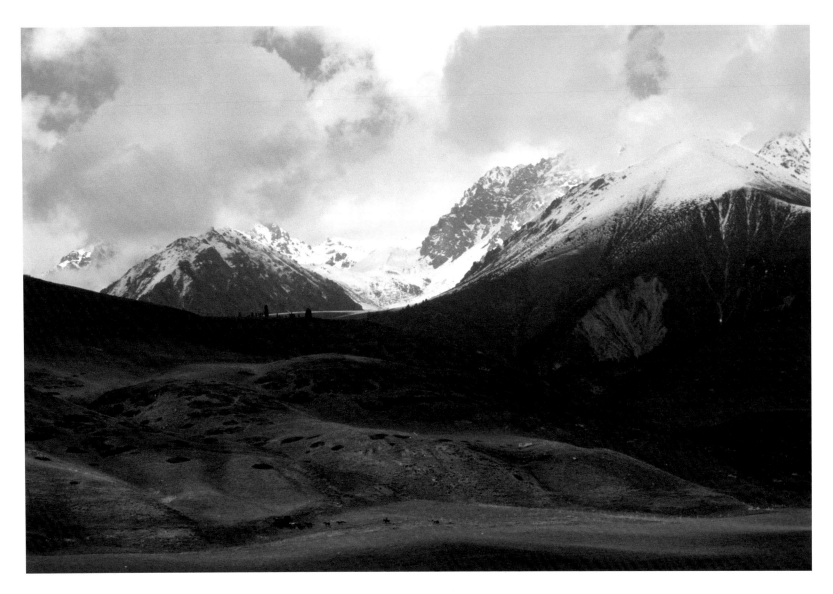

Man and the mountain
Kazakhstan

A solitary rider herds horses into the foothills of the Tien Shan. Kazakhstan is a land of steppe and mountain landscapes, and it was here that early Turkic pastoral societies embraced the beliefs of shamanism. Still practised today across the Turkic world – from the Volga in the west to eastern Siberia and Mongolia – shamanism is deeply connected to the spirit world and reveres mountains, springs, lakes and ancestors. Mountains are seen as the link between earth, man and the heavens.

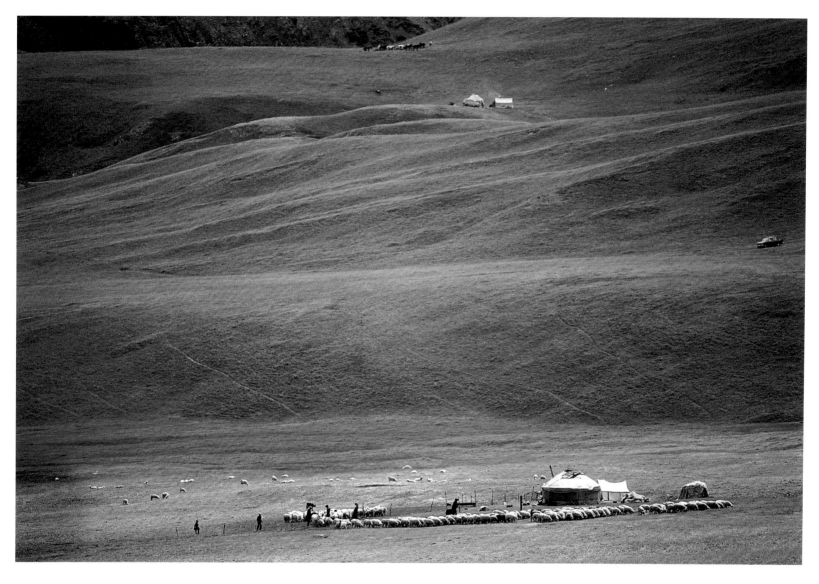

Spring in the steppe
Kyrgyzstan

This photograph, taken near Naryn in central Kyrgyzstan, shows nomads in the springtime steppe with their yurts and sheep. A Russian Lada is seen parked up on the right, and in the distance a herd of horses graze on a high ridge. Naryn was on the old caravan route to Kashgar, part of the Silk Road.

In late April, when the snows have melted and nature is on the side of the Kyrgyz, the steppe becomes an endless carpet of lush green criss-crossed with ancient sheep tracks. Different ethnic groups have evolved their own shapes and designs of yurt in response to climate. To cope with sudden heavy spring rain, Kyrgyz yurts tend to have steeper roofs than the almost flat Mongolian *gers* (page 26), which must withstand icy winds. Waterproof canvas was another gift from the Russians, along with vodka.

Herd instincts
Kyrgyzstan

By high summer, the bright green pasture of the Kyrgyz steppe is arid and overgrazed. When the end of communism in the 1990s brought economic hardship to match the harshness of the climate, many Kyrgyz turned from collectivisation to old herding traditions. Women were heroic, caring for livestock, earning a living from felt-making, and seeing to the education of children. Sheep and wool are still mainstays of the economy.

A family can erect a yurt in a matter of minutes. Every person, young and old, knows exactly what to do, which cords to tie, which ropes to pull and which flaps of felt to lay out, and just how to lay them.

Today you are as likely to see a motorbike as a horse tethered behind the yurt. Yet so central is the tent to Kyrgyz culture that the *tunduk* – the opening that forms the smoke-hole in the roof – is the sun-disc symbol at the centre of the Kyrgyz flag.

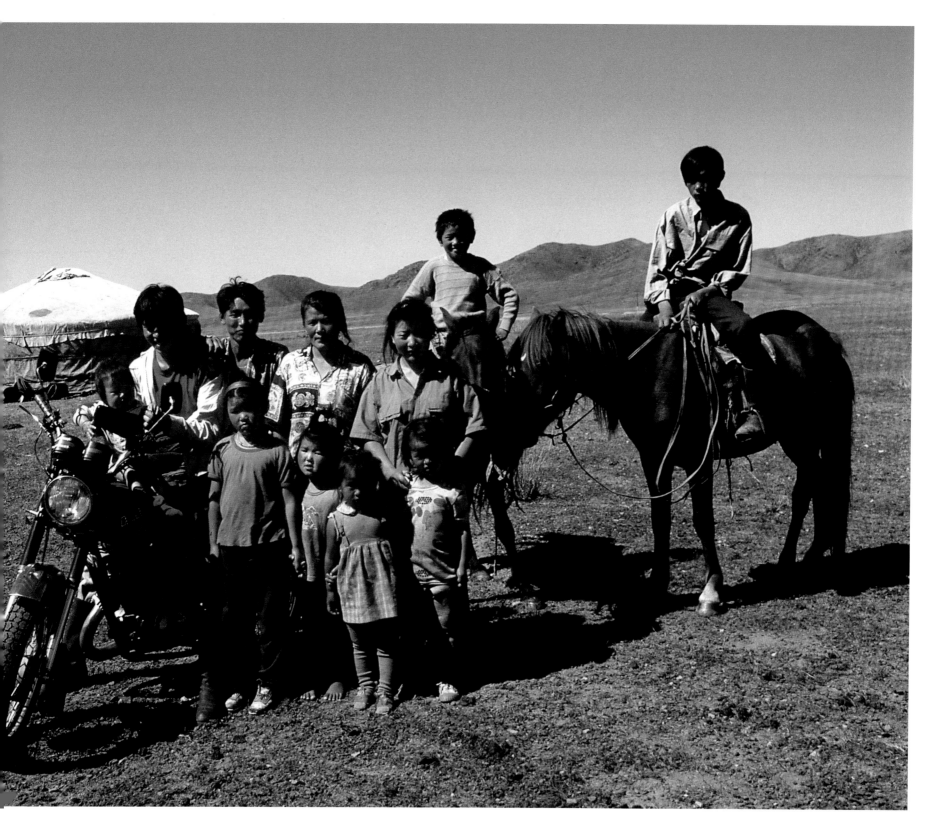

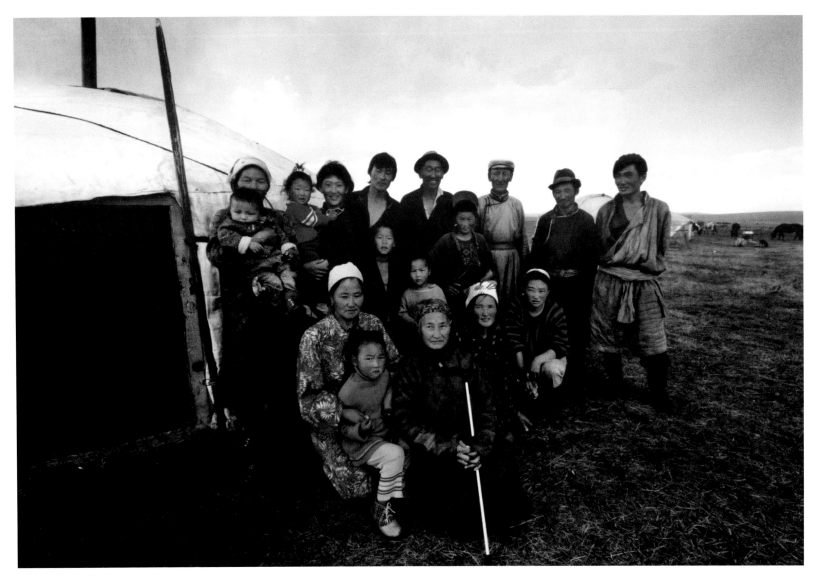

A family gathering
Arkhangai
Mongolia

Beneath a clouded pale blue sky, a Mongolian family pose outside a *ger* (yurt), with their grandmother, the head of the family. Some wear the traditional *deel*, the buttoned, long-sleeved coat with a sash at the waist akin to the *chapan* once worn throughout Central Asia. In the background mares are waiting to be milked.

Even under Communist rule many Mongolians followed grassland traditions. Nobody owned land but, following ancient practice, each family was allocated an area on which to graze their animals, ensuring that there would be no overgrazing. Today they still eat the flesh of their animals, including horses, and drink *airak* (*kumis* in Turkic). This fermented mare's milk, known to protect against tuberculosis, is light and refreshing when newly made, but an acquired

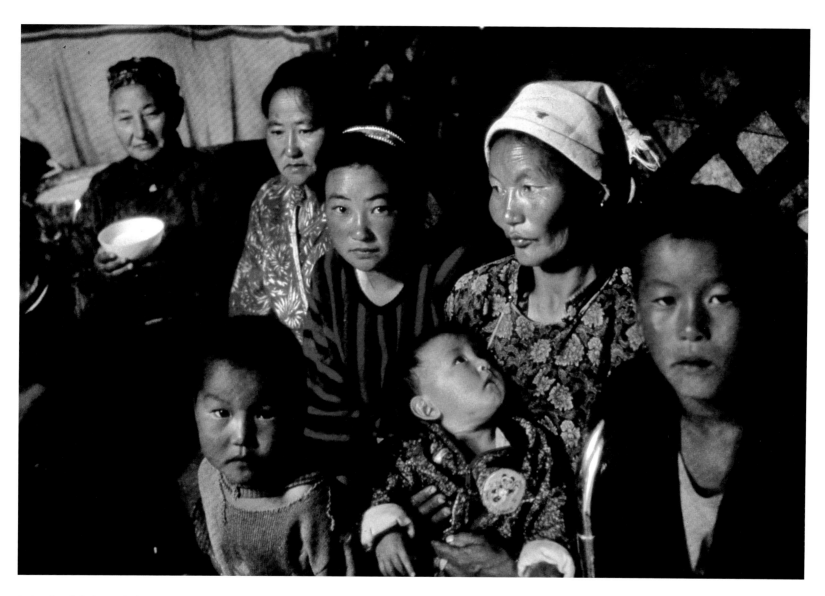

taste when fully fermented. The grandmother holds a bowl of *airak* in this photograph of the family inside the *ger* (above).

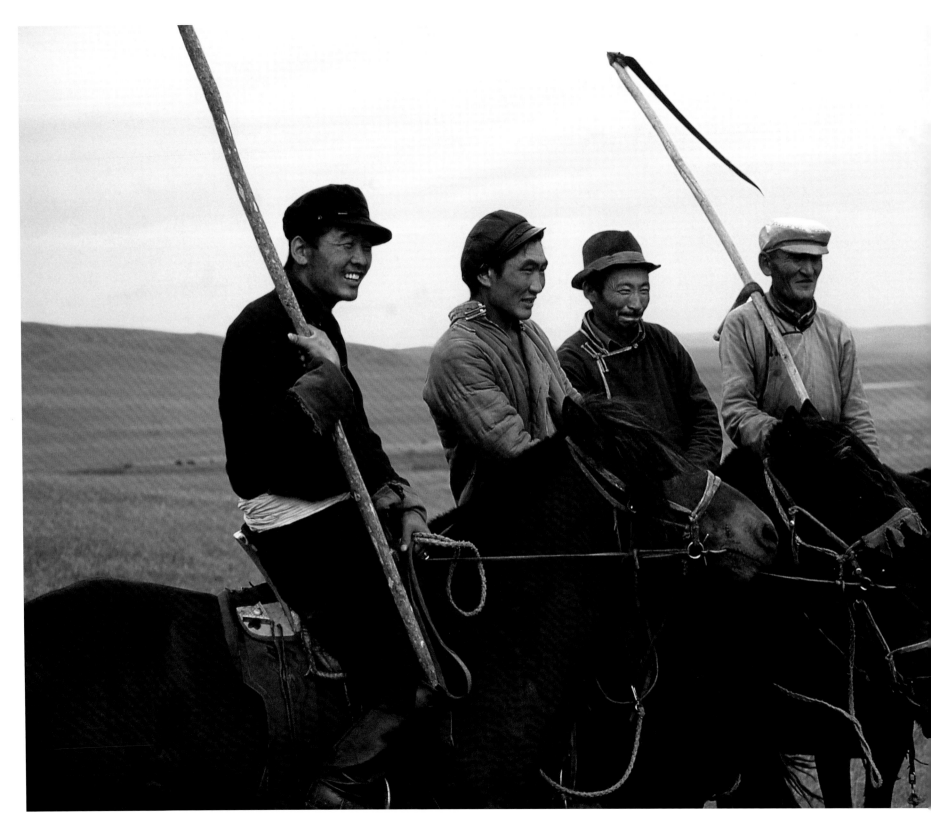

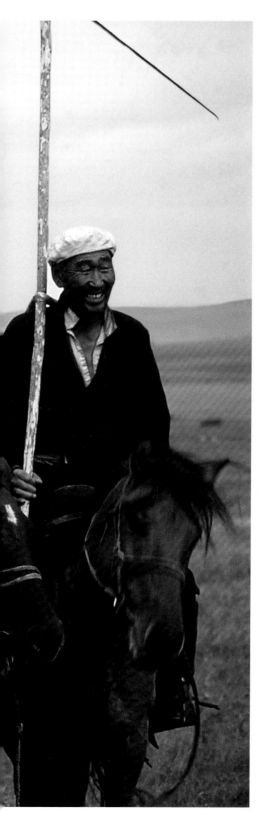

Masters of the steppe
Arkhangai
Mongolia

Mongol armies were world-famous for their mobility, and Mongolian horsemen, from one of the world's last surviving nomadic societies, are still masters of the steppelands, capable of covering vast distances and competing in daredevil chases. A carved horse even features on the national instrument, the *morin khuur*, or horsehead fiddle. In this photograph, horsemen armed with scythes have gathered for seasonal grass-cutting.

Stone of mystery
Arkhangai
Mongolia

Out on the seemingly endless Mongolian steppe, travellers may chance upon stone monuments with chiselled inscriptions or animal symbols. Mongolia abounds in such archaeological remains, although they seem few and far between.

A Bronze Age stele stands here in the low grass at Haykhan in the province of Arkhangai, where the landscape gradually changes from the desert of the Gobi to Siberian snow forest. This 'deer stone' was erected by a mysterious nomadic civilisation that built large funerary complexes from the Gobi to Siberia between 1200 and 800 BC. Known as *khirigsuur*, these low stone mounds are always surrounded by votive deposits of horses' heads and often include a large aristocratic tomb.

The most common symbols are stags with elongated muzzles and huge antlers reaching upwards. They fly like Santa Claus's reindeer towards the sky (albeit without a sleigh) and are thought to lead the way to the heavens and the afterlife.

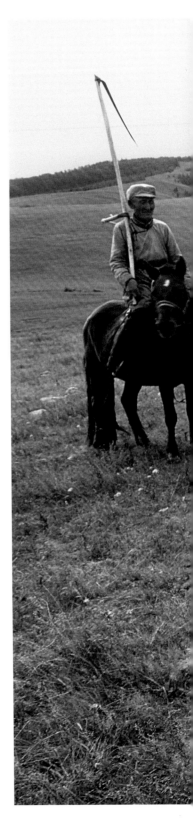

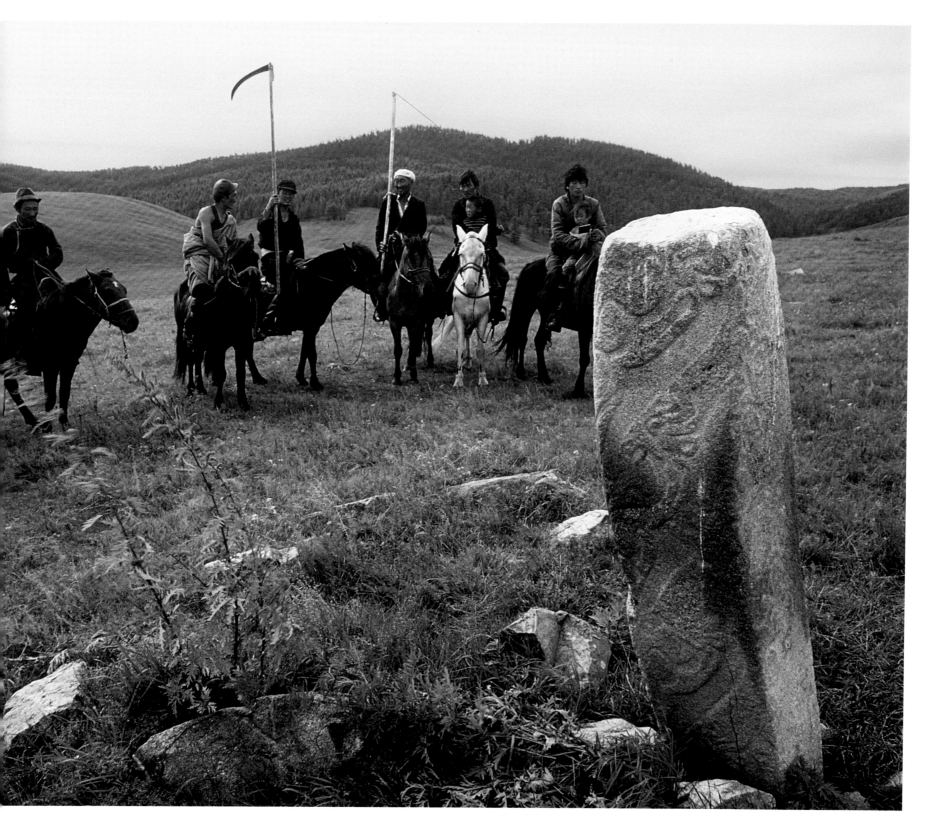

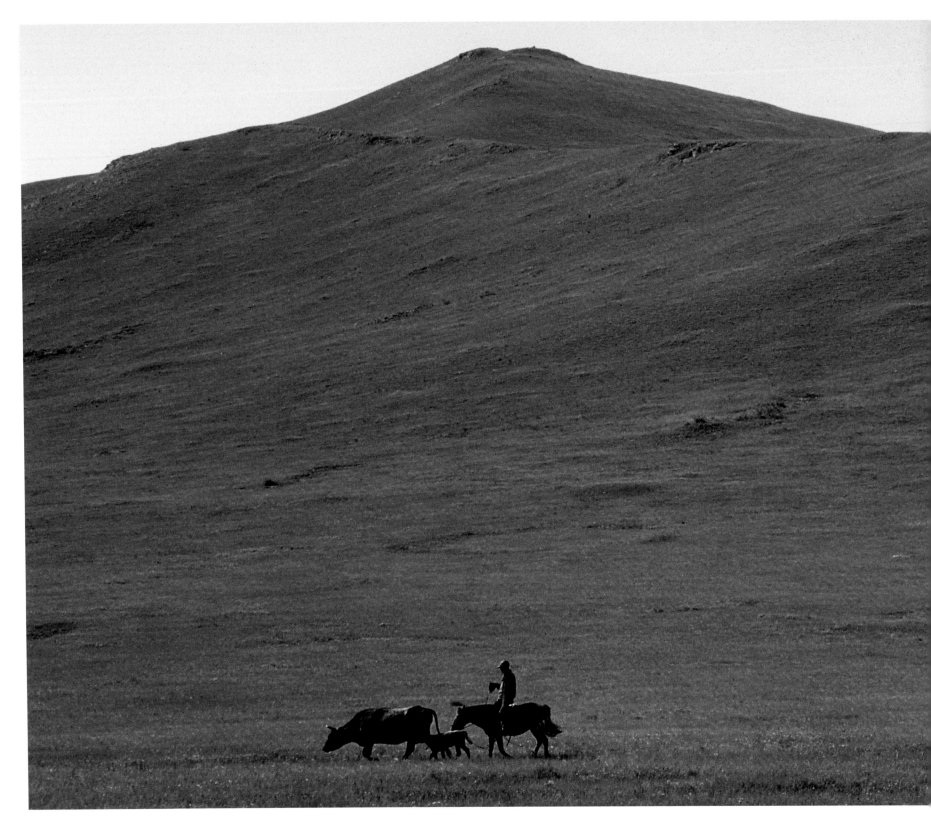

Lone ranger
Mongolia

A lone horseman rides
out in the bare foothills
of the Altai Mountains,
with a cow and a calf
for company.

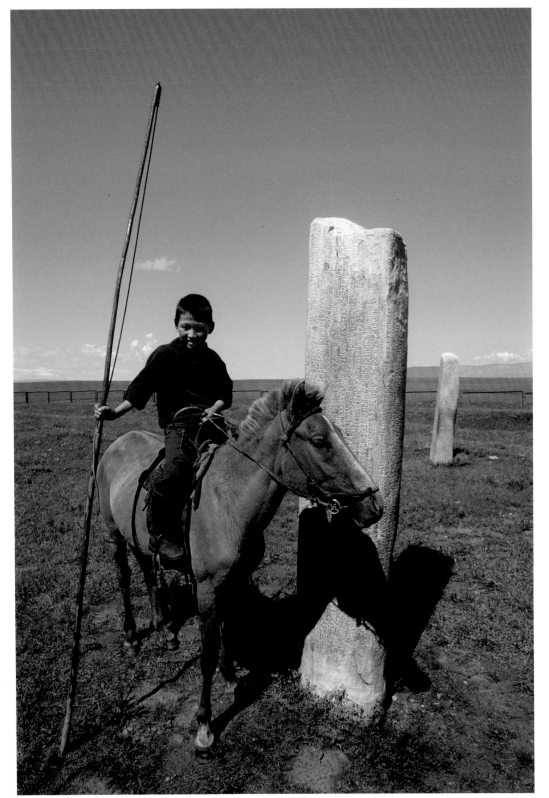

Time travel
Bain Tsotko
Mongolia

The Bronze Age ritual of raising monumental standing stones continued until at least the 8th century AD, when Turkic horsemen held sway over the Gobi Desert. Here a boy sits on his horse next to a monument dated to AD 716, which records the life and battles of his illustrious ancestor Tonyukuk in his own words. Chiselled in old Turkic script, this is the earliest known example of written Turkish.

'The wise Tonyukuk', who died in 726, was a military leader and adviser to four successive *kaghans* of the Göktürk Empire, which had ruled over the Turkic heartlands of Mongolia and Central Asia since the 6th century. His greatest achievement was his victory over the Chinese Tang Empire.

To the saddle born
Mongolia

With huge distances to cover, nomadic Mongolians are said never to walk further than the nearest horse. They operate a system of tight organisation and careful division of labour in which children must play their part. This boy holds an *urga*, a kind of lasso attached to a long pole, used for catching horses.

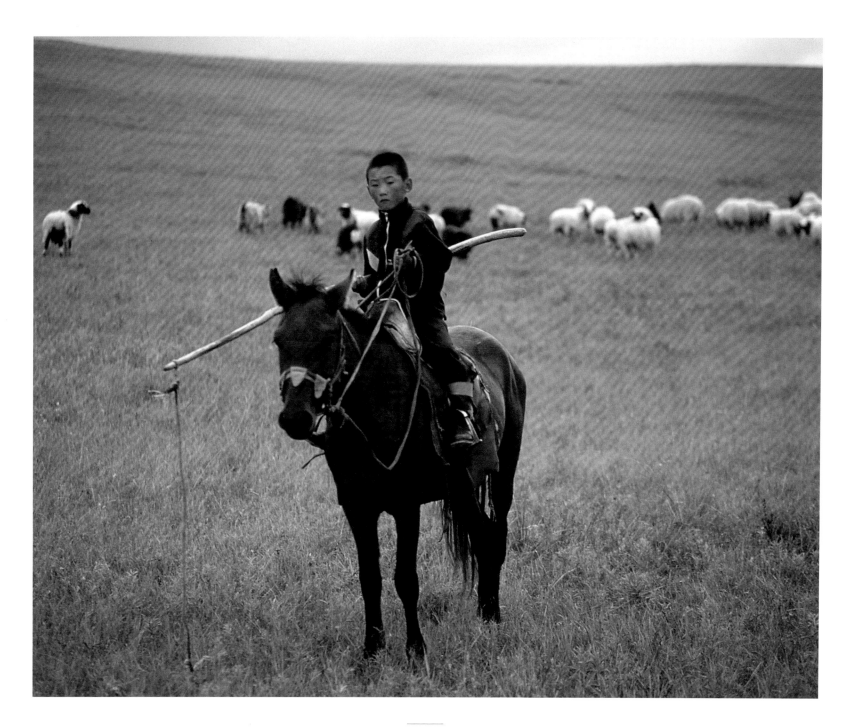

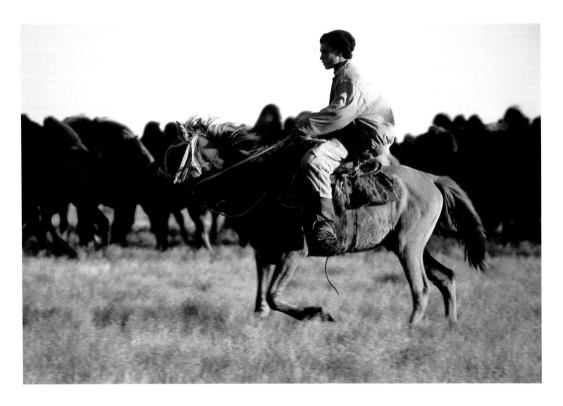

The camel herder
Kazakhstan

Along with Mongolians, Kazakhs are renowned as the 'cowboys of the East' for their skill in herding and horsemanship. It was around 3500 BC, on the steppes of prehistoric Kazakhstan, that horses were first domesticated.

The horse has long been venerated. In Greek mythology, the winged horse Pegasus was the son of Poseidon, lord of the sea, storms and horses. The Yakut people of northern Siberia have also given god-like status to their horses, which have extremely thick coats and are able to snuffle under the snow for food.

The boy seen here on the Kazakh steppe is herding Bactrian camels. Once kings of the Silk Road, camels have inevitably been replaced by trucks, trains and planes. But they are still kept in Kazakhstan and Mongolia for their fatty milk, and for transporting dismantled yurts across pasture and steppe.

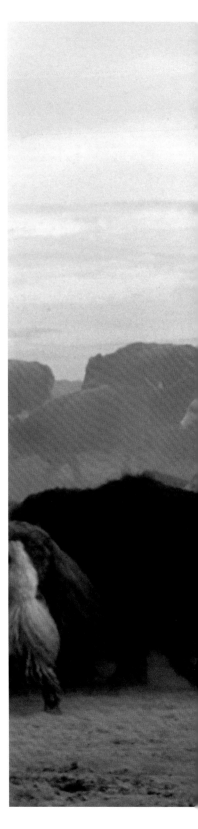

Yaks at twilight
Mongolia

In this photograph, taken in the Gobi Desert between Karakorum and Ulaanbaatar, mounted herdsmen drive a herd of yaks with silky black and white coats across the steppe at twilight. Domesticated and crossed with cattle thousands of years ago, yaks in Mongolia are used for wool and meat and to transport goods. On the steppe, they are milked, along with cows and camels, and their dried dung is used as fuel.

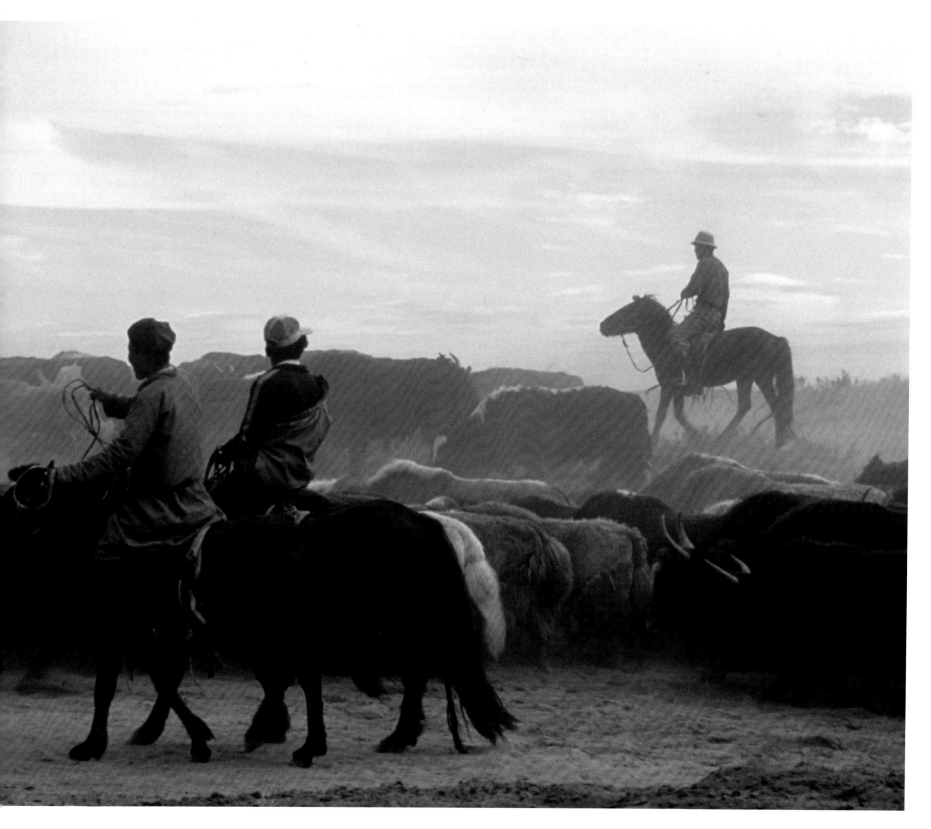

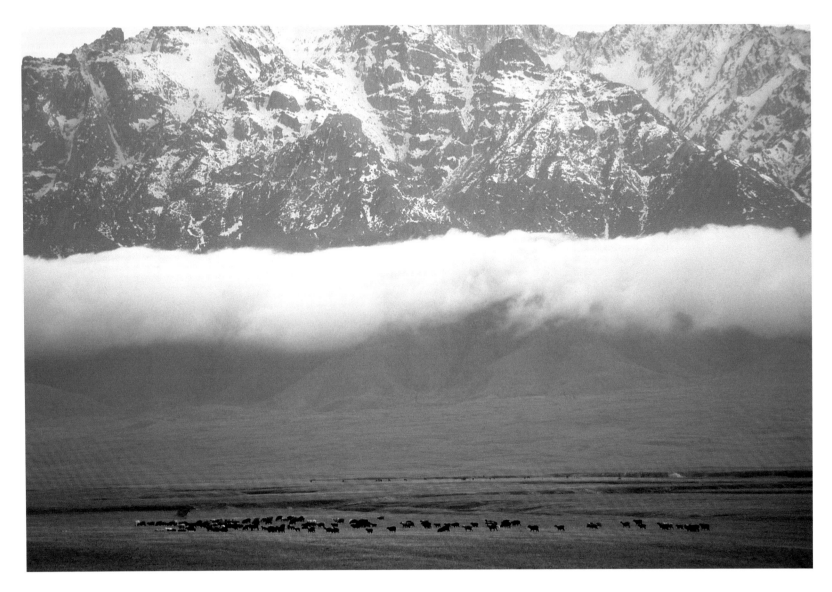

Pastoral ways
Kyrgyzstan

Almost all of Kyrgyzstan's borders run along jagged mountain crests. Here the snowy Tien Shan rise above a thick band of cloud, forming a surreal backdrop to grazing

flocks of native fat-tail sheep – black, brown and grey. While much of the pasture is severely overgrazed, national parks have continued to expand in the mountains,

helping to preserve the snow leopards, Siberian ibex and other fauna. Also protected to some degree are endangered mountain forests, with their ancient stands of walnut and rare

apple trees. However, only one reserve in the Tien Shan bans grazing outright: the majestic Aksu-Dzabagly Nature Reserve, just across the mountains in Kazakhstan.

Botanists report a remarkable difference in the flora outside and inside the reserve.

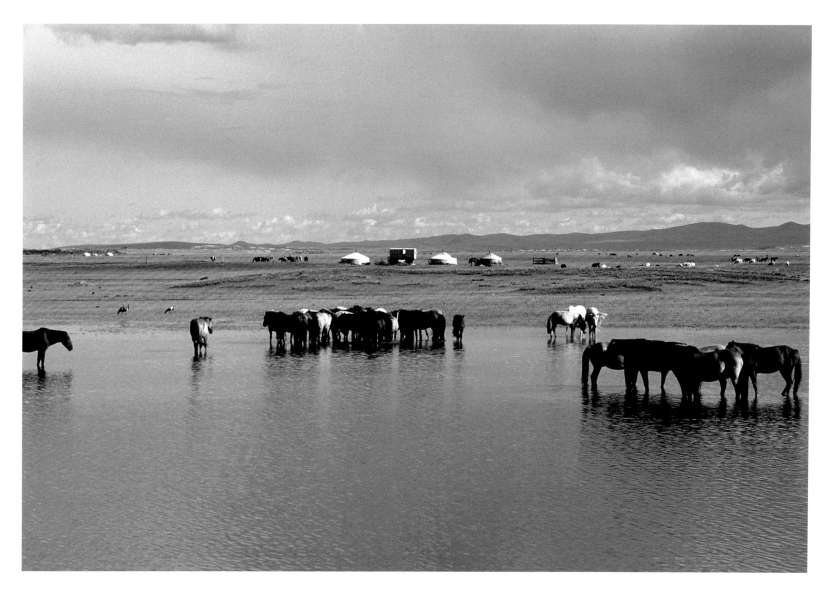

A long, cool drink
Mongolia

Several families have set up their white *gers* here, in an ideal environment for nomads, with grassy pastures and plenty of water for their animals. Horses are central to Mongolian survival. Herds may appear wild, often gathering in very remote locations, but horses usually belong to families.

Rich in back fat and prized for their milk, they are widely eaten in Mongolia and Kazakhstan, but generally a herdsman will not slaughter a horse he has ridden.

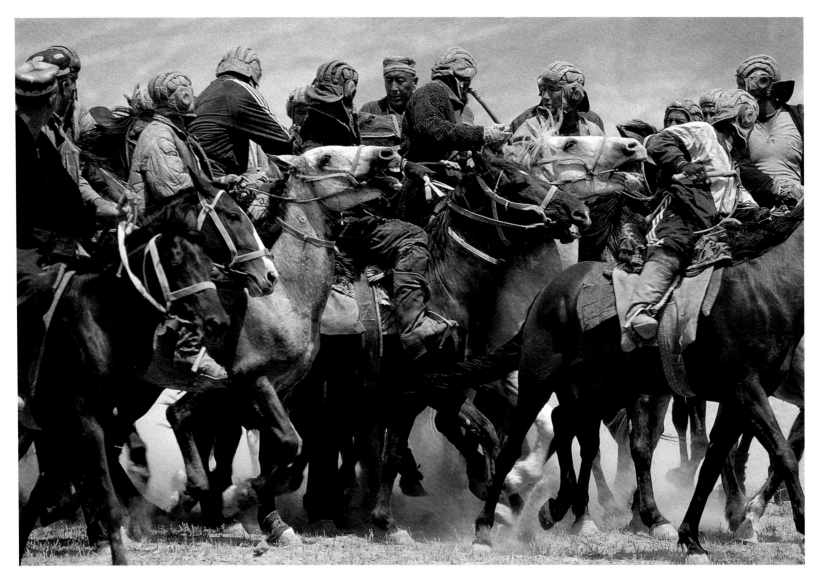

The wildest sport
Boysun
Uzbekistan

Soviet-era tank helmets help protect riders (*chapandaz*) against whips, thundering hooves and elbows in the game of *buzkashi* (literally 'goat-grabbing' in Dari).

Known as *oghlak tartysh* in Turkic, this is the world's wildest equestrian sport, a hazard even for spectators, as riders charging across the steppe may surge into

onlookers. This contest took place in Boysun in southern Uzbekistan, once on the trade route to India, now an isolated UNESCO centre of 'Intangible Cultural Heritage'.

An eye on the prize
Boysun
Uzbekistan

This handsome helmeted rider was photographed during the games at the Boysun Bohari spring festival, held every May. The winner may carry off a camel, a car or a TV.

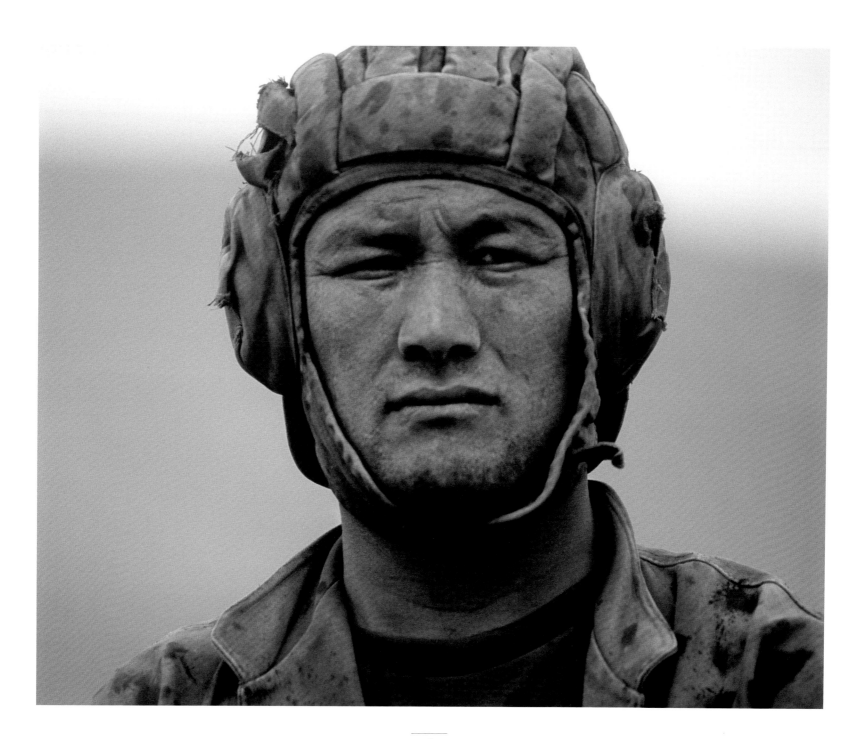

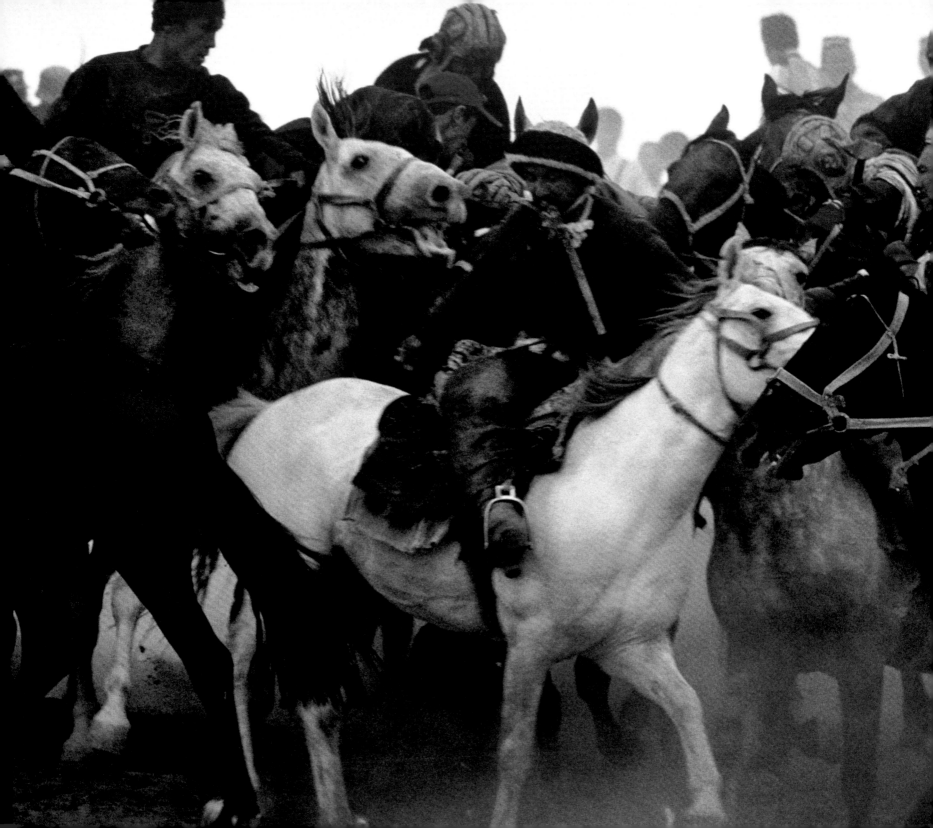

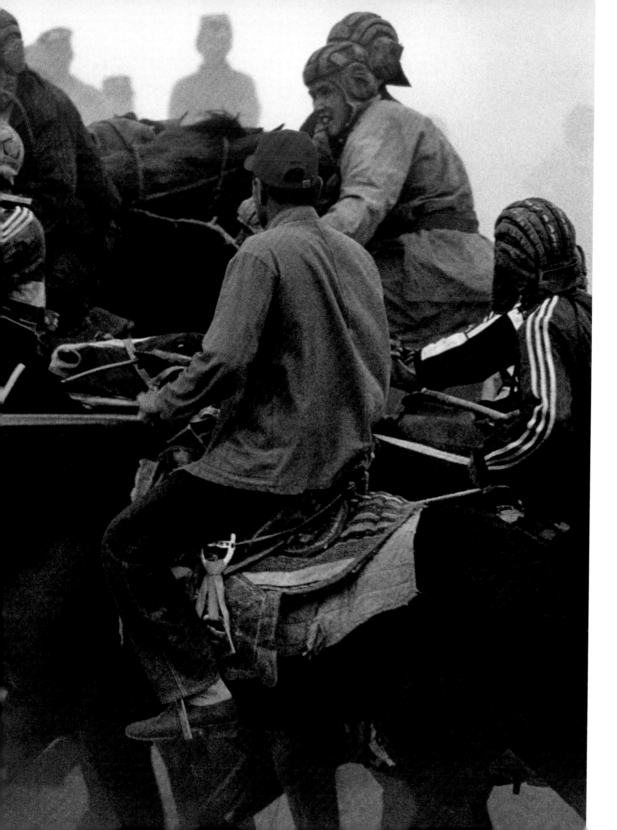

Hooves of thunder
Boysun
Uzbekistan

Heads up and tails flying, a team of horses scrum through mud, dust and sweat, racing for the headless *buz* or *oghlak* (goat carcass). Riders lean dangerously low to pick it up or drag it to the goal line while avoiding the lashing whips of their competitors.

Believed to have begun when Turkic nomads filtered down from the northern steppes, *buzkashi* was, according to legend, first played in the basin of the Amu Darya (the ancient Oxus). Today the sport is popular in Uzbekistan, Kyrgyzstan, Tajikistan and northern Afghanistan.

Water worlds
Mongolia

In contrast to southern Mongolia, the north of the country still has many freshwater lakes, some a million years old.

Khuvsgul, Mongolia's largest lake, close to the border with Tuva, is one of 17 in the world that are two million years old. Considered the 'younger sister' of nearby Lake Baikal, it freezes over in winter and for years was used as a highway by trucks. These are now banned after a series of accidents in which vehicles fell through the ice and polluted the pristine waters.

Southern Mongolia was also once a land of water worlds teeming with life. In the now-arid canyons of the Nemegt Basin in the Gobi Desert, the most remarkable fossil finds have been made – dinosaur bones by the ton, thousands of dinosaur eggs and the bones of early mammals that lived alongside them.

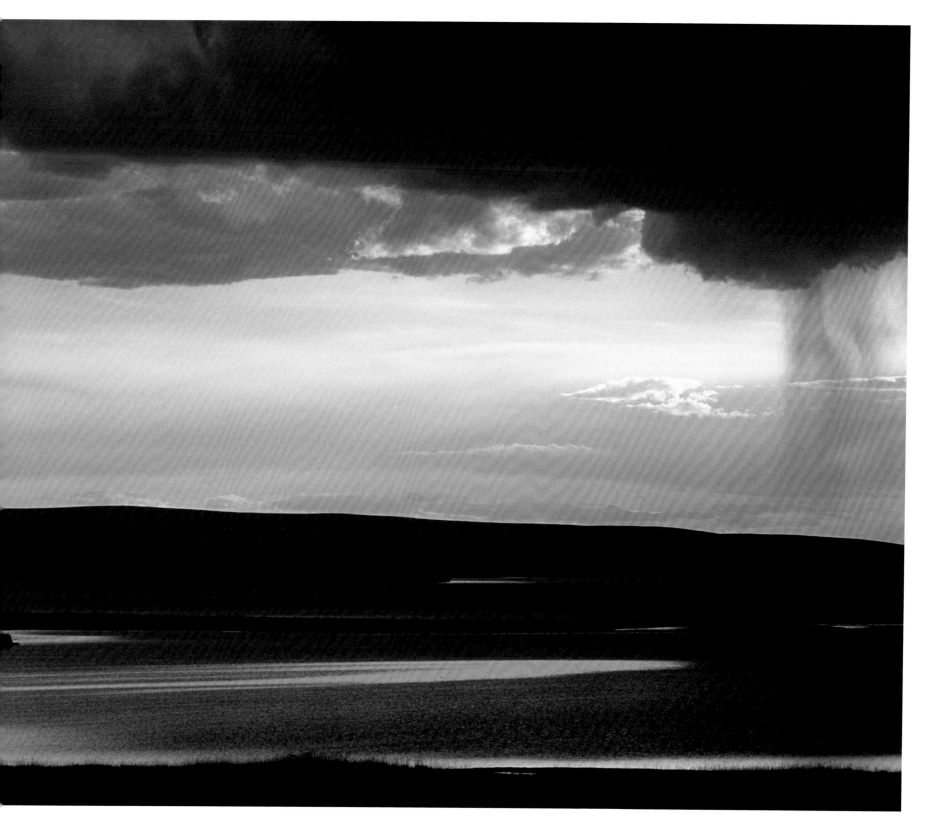

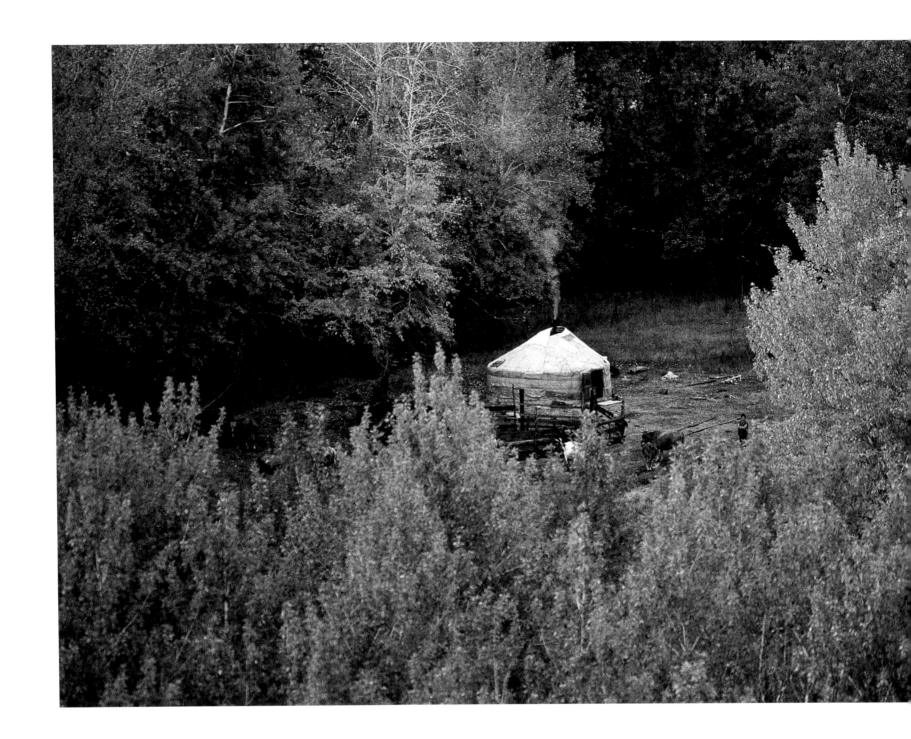

A forest yurt
Tuva, Russia

A smoking yurt in a forest clearing in Tuva, southern Siberia. Far from the epicentre of Russian power, Tuva has much in common with neighbouring Mongolia. Native Tuvans are a Turkic people with a tradition of yurt dwelling.

Like many Mongolians (and the 'Sary', or 'Yellow', Uyghurs of western China), they adhere both to shamanism and to Tibetan Buddhism after living under Mongol and Chinese rule for centuries. The Dalai Lama is their spiritual leader.

Tuvans enjoyed a brief period of independence as the Tannu Tuva People's Republic from 1921 to 1944, before being swept up by the Soviet Union at the end of the Second World War.

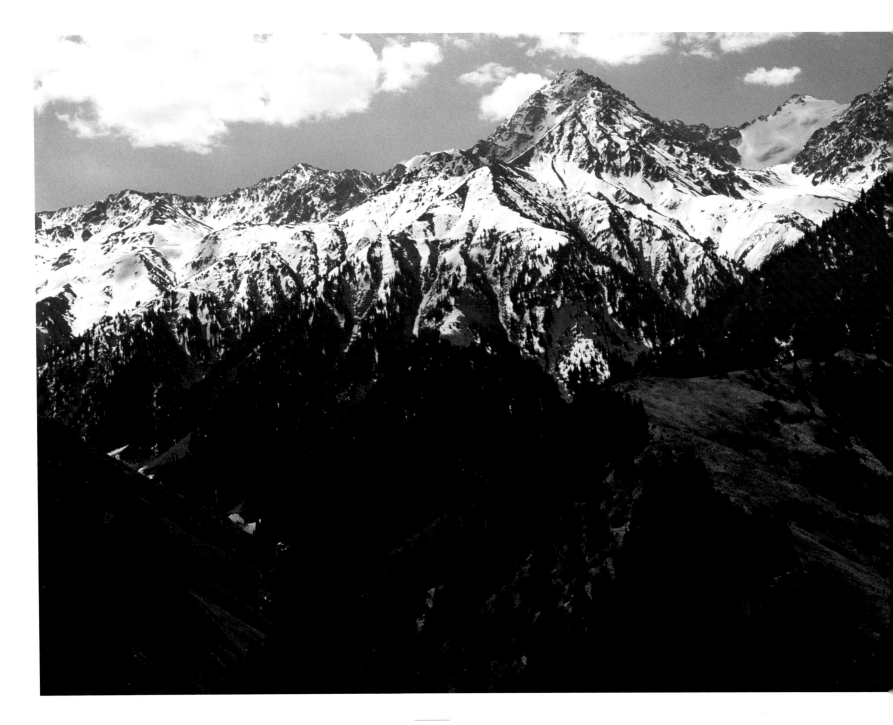

Alps of the East
Kazakhstan

With its lowlands, plains, valleys and canyons, Kazakhstan has enviably varied landscapes, none more impressive than its mountains. The 'Alps of the East' include the snow-covered peaks of the Tien Shan that dominate the border with Kyrgyzstan, and the lakes, glaciers and endless rivers of the Altai range, which spill over into Mongolia and the Russian republics of Altai and Tuva.

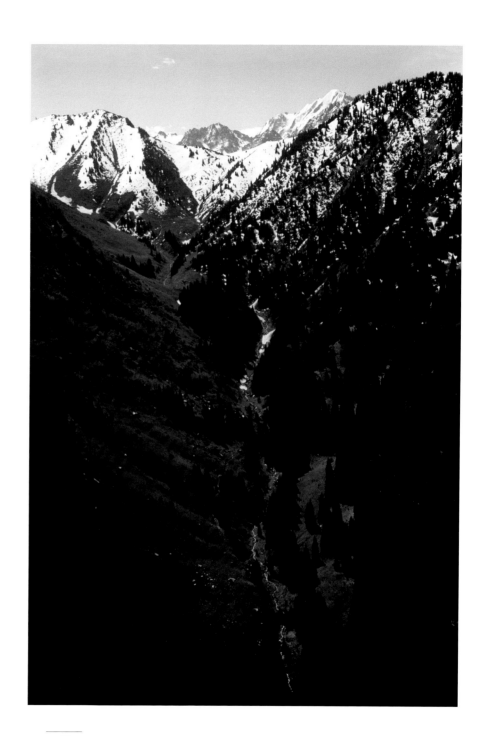

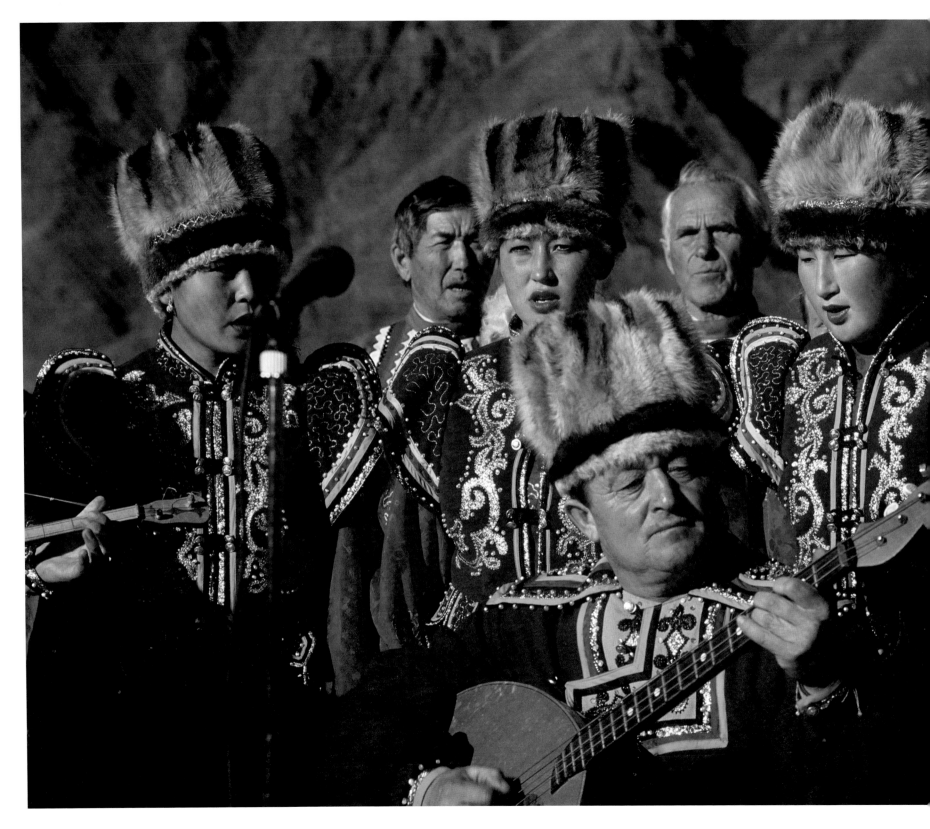

Between heaven and earth
Onguday
Altai, Russia

Music in Altai resonates with the sounds of the natural world, often accompanied by haunting throat-singing. Altaians hold a deep shamanist belief in an eternal blue-sky spirit and a fertile earth spirit, revering ancestors and landscapes.

Performing at a festival near the Altai capital, Gorno-Altaysk, the women here wear stage costumes that include the traditional *chegedek*. At one time no married woman in southern Altai would be seen without this winged jacket. If her husband died before her, she would put it away until her death, when she would be buried in it. The yellow, red and green bands, which authentically would be embroidered, recall the goddess Umay, protector of mothers and children, who descends from the heavens on a rainbow bridge.

The fur hats, or *börüks*, recall the old *bays* (landowners), who traded sable and squirrel skins with the Chinese for silk and bars of silver.

Shamanic rhythms
Tuva, Russia

Although the Altaic Tuvans are now predominantly Buddhist, they still practise shamanism in this land of forests, lakes and ancient Scythian sites.

Shamans, often women, possess a deep knowledge of nature, animals and plants and are valued as healers and spirit doctors.

Central to shamanism is drumming – believed to be reverberations from the sky – and shamans dance to its rhythms to ward off spirits or to journey to other times and places.

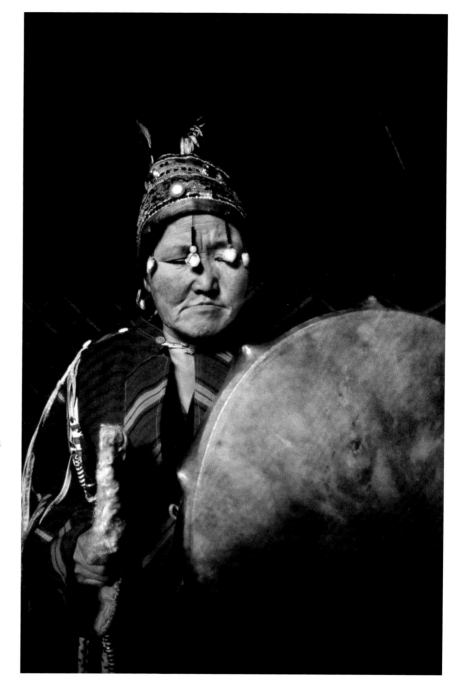

Dance in a cold climate
Kazakhstan

Children's dance ensembles are popular in Kazakhstan, with troupes including skilled performers aged anywhere from four to 16. Music, epic poetry and dance have played a central role in Kazakh culture for centuries, accompanying every major life event. Traditional Kazakh instruments, such as the double-stringed *dombra* and the ancient bowed two-stringed *kobyz*, are used extensively by folk orchestras.

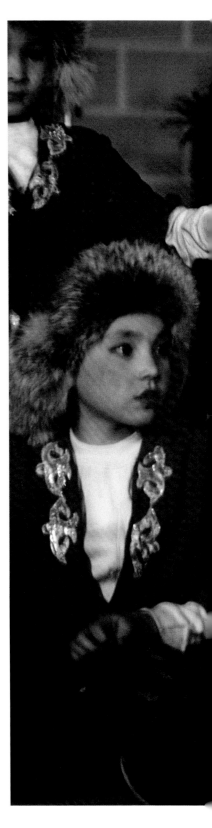

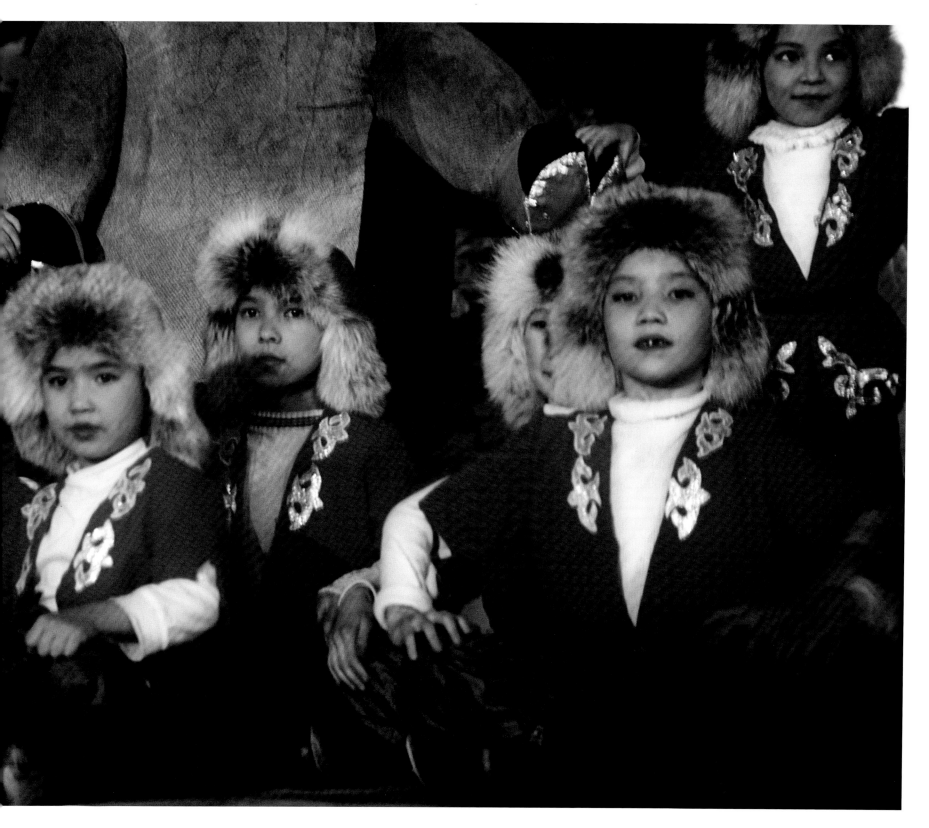

Turks of the tundra
Yakutia, Russia

Shepherds watch over
their reindeer on the
frozen tundra of northern
Siberia. Their loyal, hard-
working, shaggy dogs are
an ancient breed of Laika
developed for herding,
sled-pulling and hunting
and known locally as
Sakha yta (Yakutian dogs).
 Another ancient
Turkic-speaking people,
the Yakuts number about
half a million and still
follow some form of
nomadic lifestyle, moving
between summer and
winter camps, sometimes
riding the reindeer. These
'Siberian Turks' herd
deer, hunt and fish in the
northern part of their
territory, while in the
south they tend to be
cattle- and horse-breeders.
 This photograph
illustrates the vast
distances that Çağatay
travelled to document the
lands of Turkic speakers.

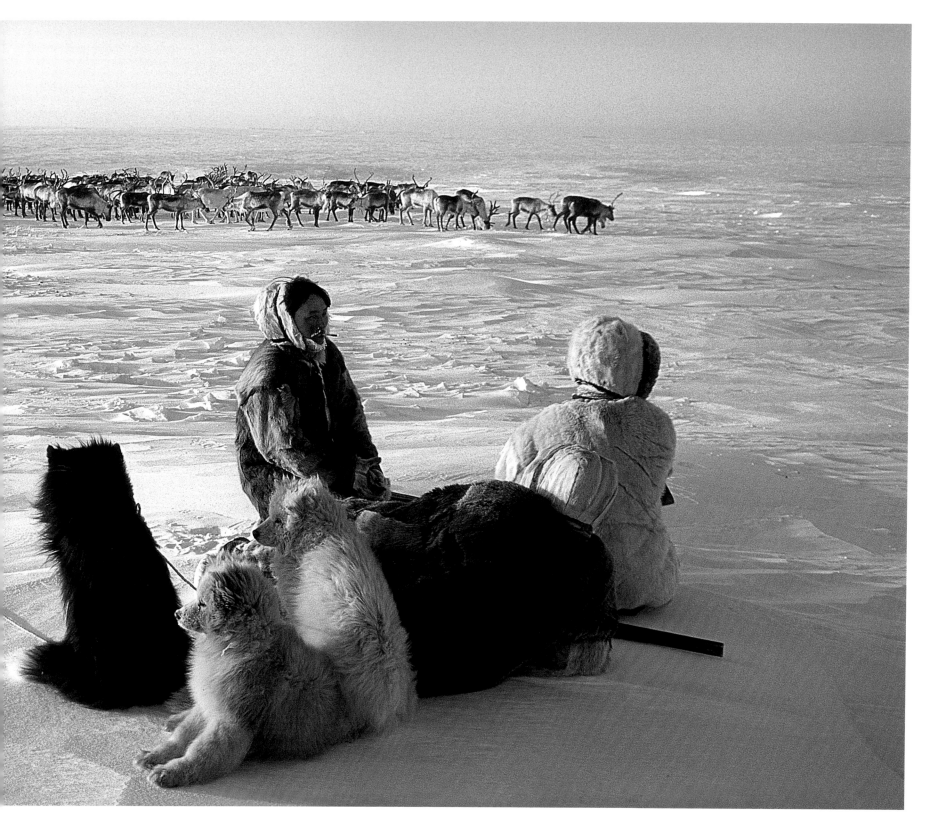

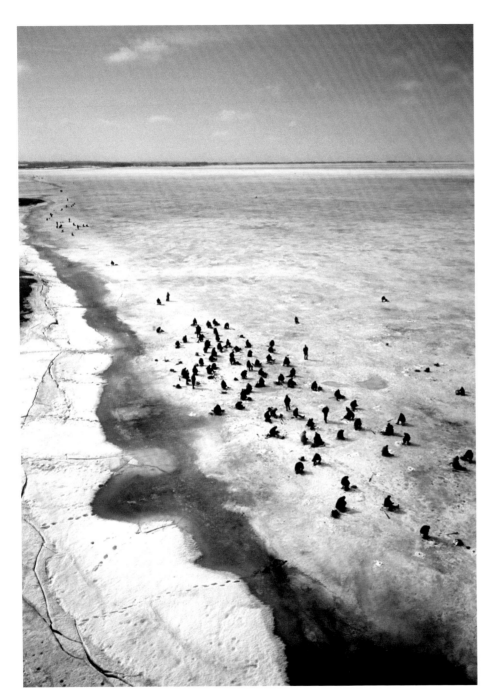

The waiting game
Kazan
Tatarstan, Russia

Ice-fishing on Europe's longest river, the Volga, near Kazan, capital of Tatarstan. Fishermen drill a hole in the thick ice, drop a line into the water and wait patiently for an eel or sturgeon to bite. Turkic people living along the Volga refer to it as the Etil. Tatars are descendants of the Khazars, the Volga Bulgars and the Golden Horde, who ruled the region for centuries. Since 1552 they have been the principal Muslim community in Russia.

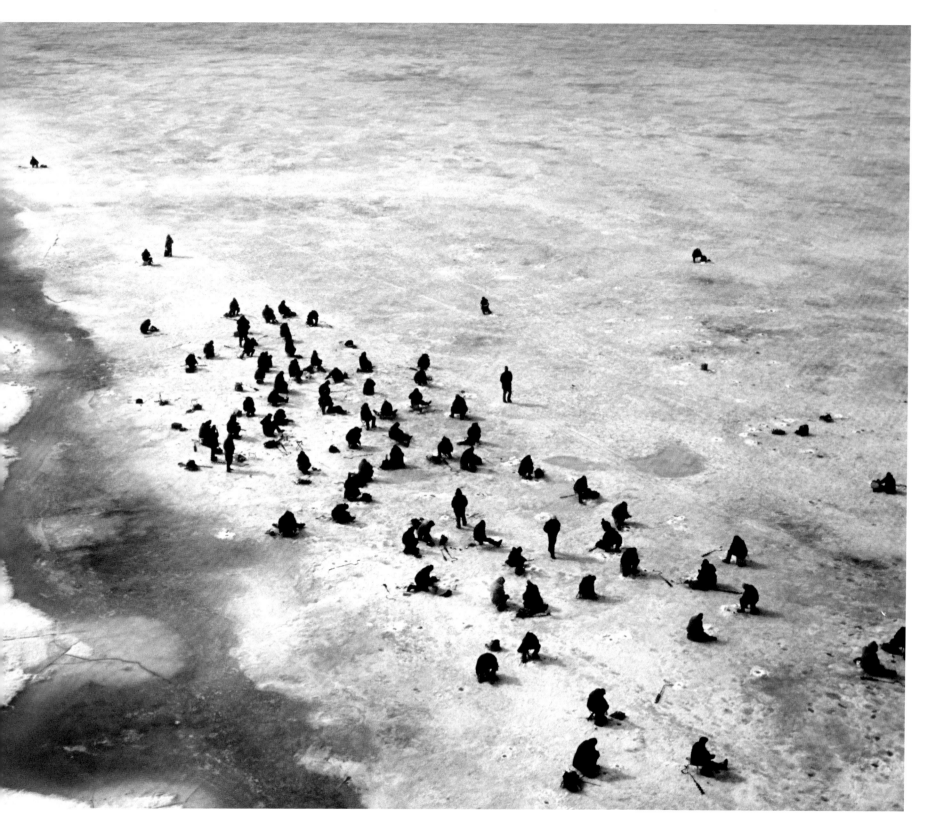

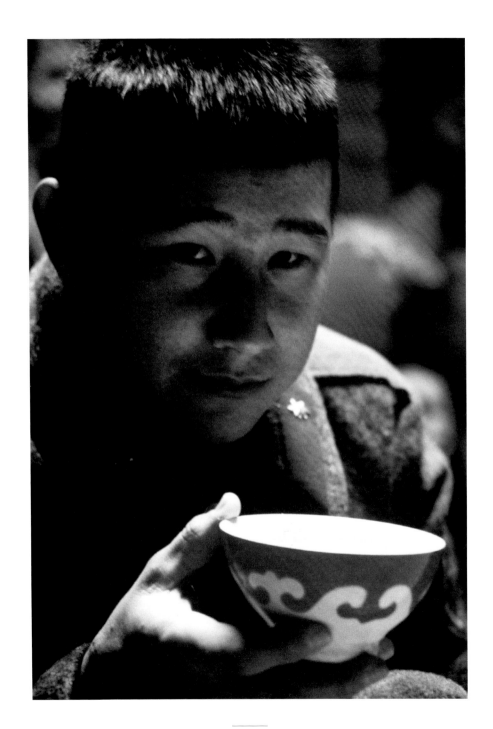

Timeless symbols
Kazakhstan

A Kazakh cadet drinks from a bowl decorated with characteristic Central Asian motifs. The scrolling horn and 'cloud band' are patterns derived from sacred Neolithic symbols representing strength and protection. They are found in embroideries and felt, yurt decoration and saddle ornaments.

Next-generation nomad
Kazakhstan

This smiling woman holding her young son outside their yurt continues a 3,000-year-old pastoralist tradition. Few Kazakhs live in them today, but yurts remain a key symbol of their cultural heritage and identity post-independence.

Turkic peoples are semi-nomadic rather than strictly nomadic. Instead of wandering, they have winter villages (*kishlaq*) and summer pastures (*jaylau*, or *yayla* in Turkish). Traditional laws governing the steppe draw clear boundaries between pastures, villages and roads. The equinox heralds either the great walk to the pasture or the return to the village.

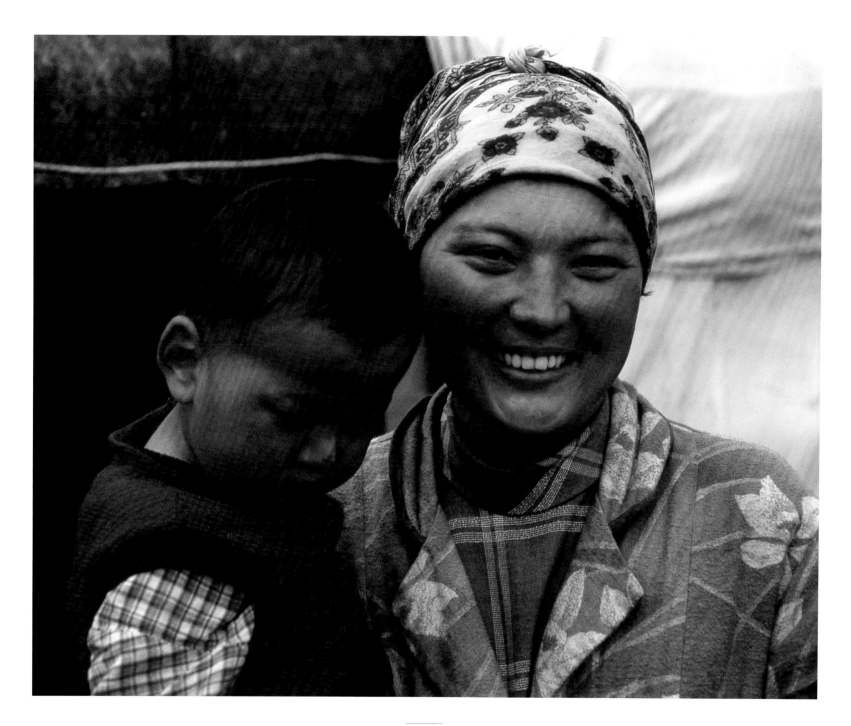

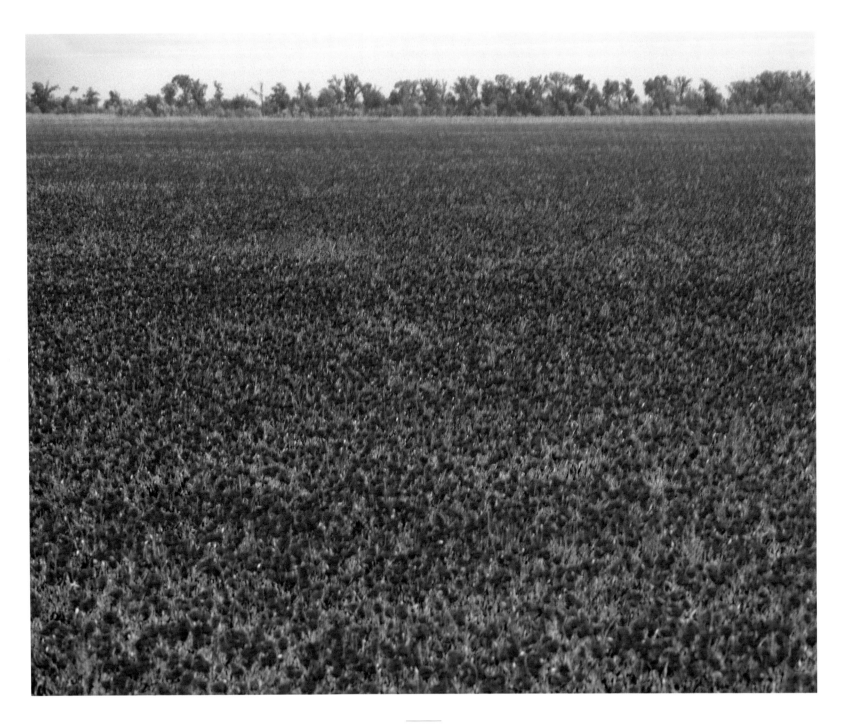

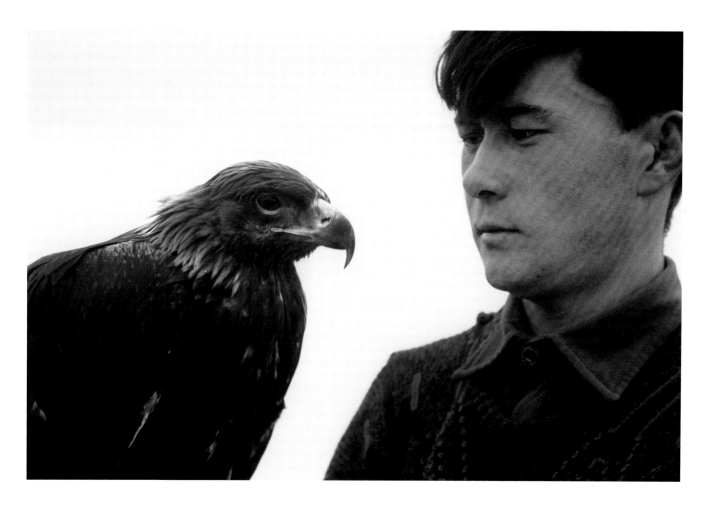

Red carpet
Kazakhstan

In the summer, the steppe of southern Kazakhstan turns blood-red with poppies as far as the eye can see. The display lasts a few weeks, and families can often be spotted leaping out of their vehicles to take photographs among the flowers.

A lasting bond
Kyrgyzstan

Falconry is still practised in Central Asia, especially in Kyrgyzstan and Kazakhstan and, beyond the Tien Shan and Altai Mountains, in China and western Mongolia. The Kazakh-speaking Mongolian town of Ölgii is noted for its annual golden eagle festival, celebrated in the film *The Eagle Huntress*.

The golden eagle (Turkic *berkut*), the bird of choice, is referred to as a 'booted eagle', as it is feathered down to its talons. Golden eagles are rarely used in falconry elsewhere, as they lack versatility (they hunt primarily over open ground) and are hard to train.

Among the largest species of bird in the world, they have a wingspan of more than two metres, which makes foxes, marmots, hares, owls, even steppe antelopes fair game.

The chicks are taken from the nest to be tamed, and the fully grown birds are released into the wild when they are ready to breed. Occasionally they meet their old masters on the steppes and are said to recognise them.

The eagle hunter
Kyrgyzstan

Hunting with eagles on horseback is ingrained in the Kyrgyz and Kazakh cultures, with know-how passed down the generations of eagle falconers, or *berkutchis*. The hunter's trappings include the heavy leather glove used to handle the bird (known variously as the *meelai* or *bialai*), and the *tomaga*, the cowhide hood used to blindfold the bird when it is not feeding or being flown.

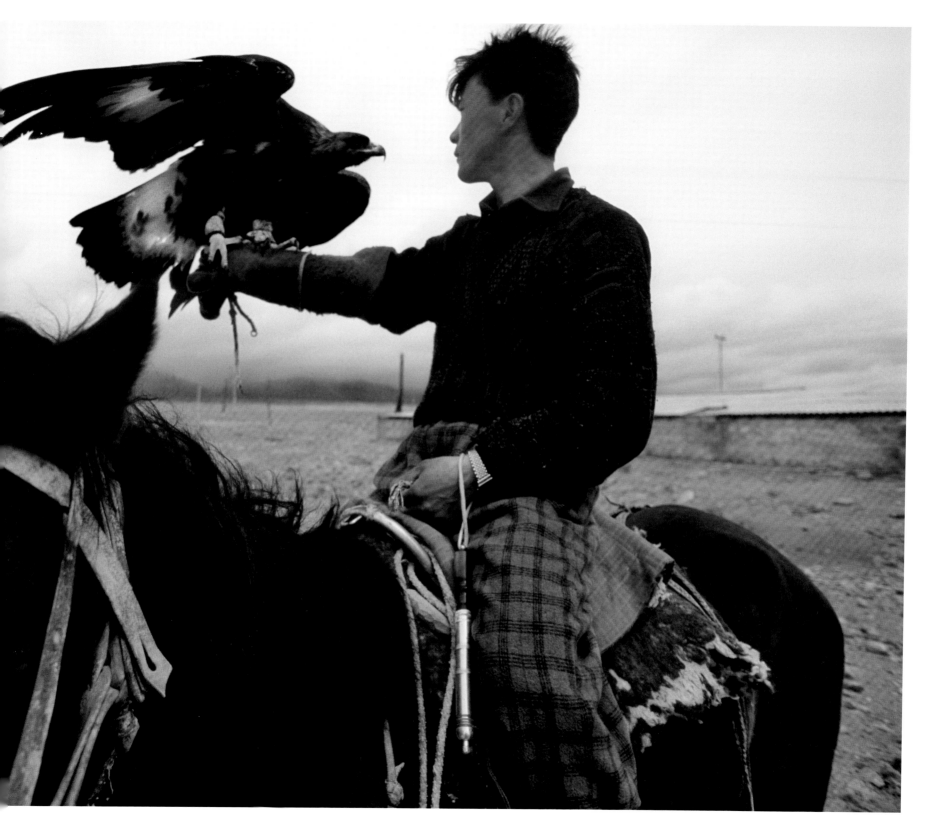

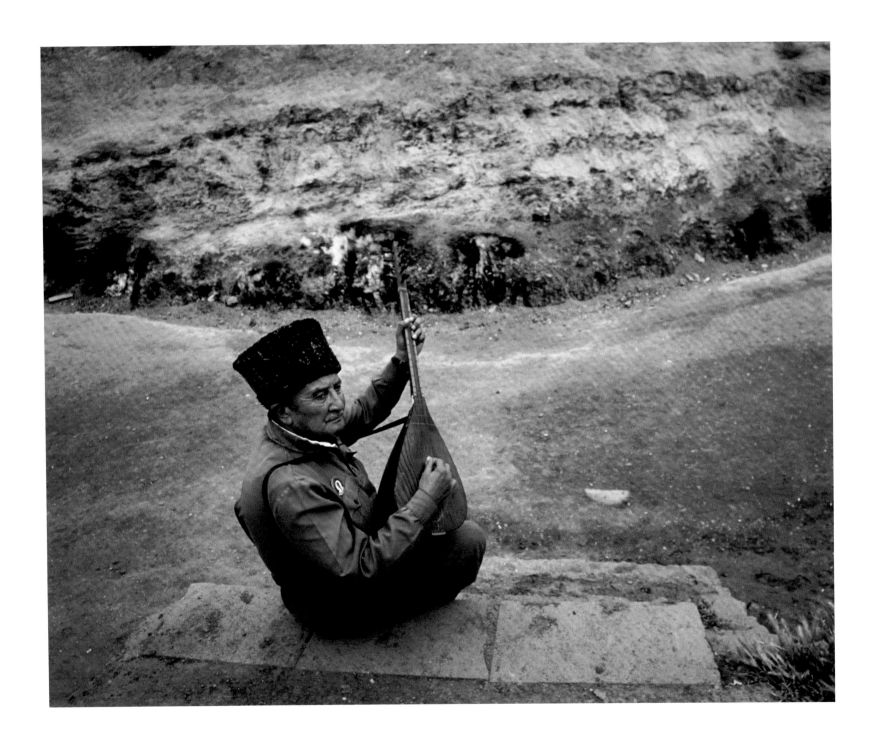

The burning mountain
Baku
Azerbaijan

A *saz*-player on the Absheron Peninsula, which extends into the Caspian Sea. Marco Polo noted mysterious flames licking up from the ground on this peninsula, where natural gas leaks to the surface. Today, the last place where gas still burns in the vicinity is Yanar Dağ (Burning Mountain, actually more of a hill than a mountain) on the outskirts of the capital, Baku.

Azerbaijan means 'Land of Fire', which recalls the Zoroastrian beliefs of this region before the arrival of Islam. Fire linked the human and supernatural worlds.

The smoker
Uzbekistan

In Central Asia, designs on the ubiquitous cap often give clues to the wearer's social status and birthplace. This man smoking a cigarette in a pipe sports a *Chust doppi*, an elegant square hat with fine white embroidery on a black background. Hats like these originated in the ancient city of Chust in the Fergana Valley and were later widely adopted in the oasis cities of Uzbekistan. Frequent motifs are almonds (*bâdâm* in Uzbek), symbol of wealth and fertility, and pepper pods (*kalampir*) to ward off the evil eye. These hats have recently regained their traditional ritual character, being worn, for example, on visits to mosques and at funeral ceremonies. They are also presented to esteemed guests.

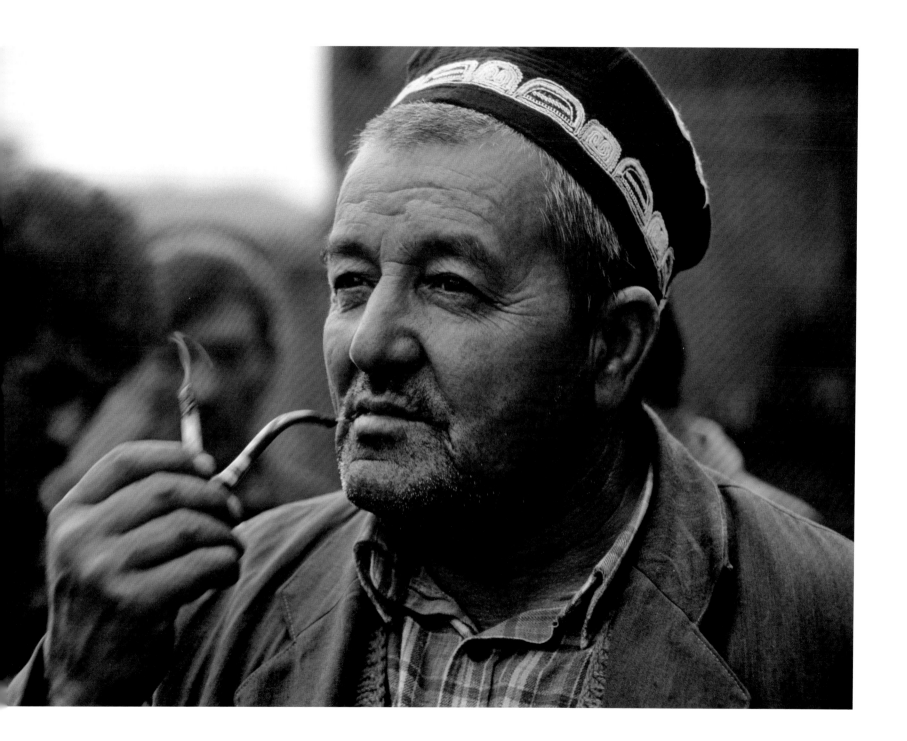

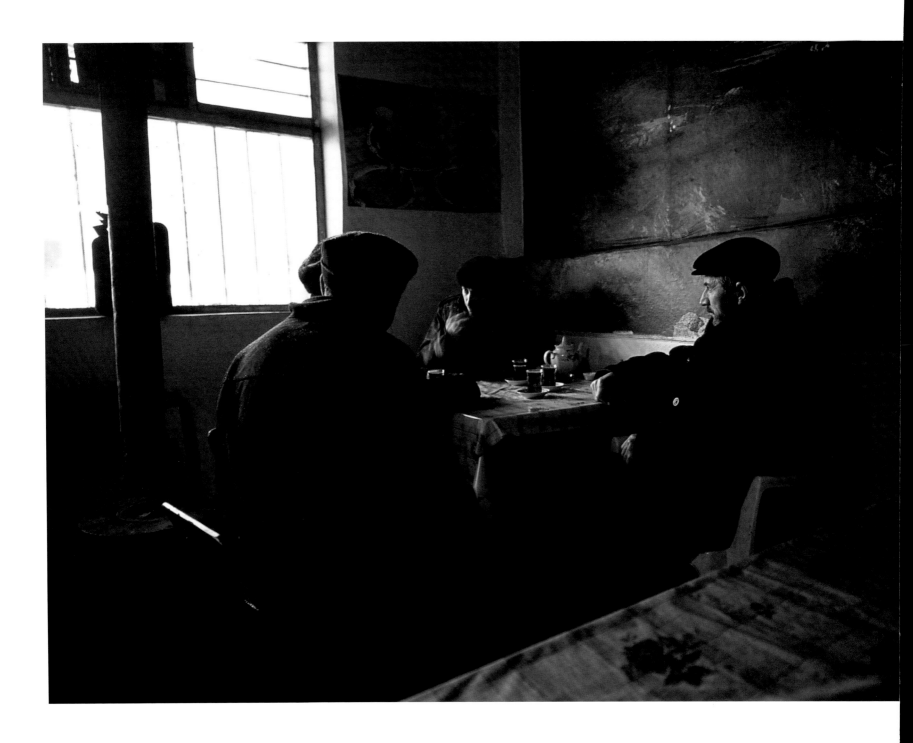

Conversation piece
Azerbaijan

From Kabul to the
Caucasus, the *chaikhana*,
or teahouse (*çayhane*
in Turkish), is as much
a meeting place as the
mosque, and men can be
found here (it is nearly
always men) whiling
away the hours in earnest
conversation. Like figures
in an Impressionist
painting, these Azeri
men quench their thirst
with glass after glass
of tea, delivering
tales of old conflicts and
exchanging news.

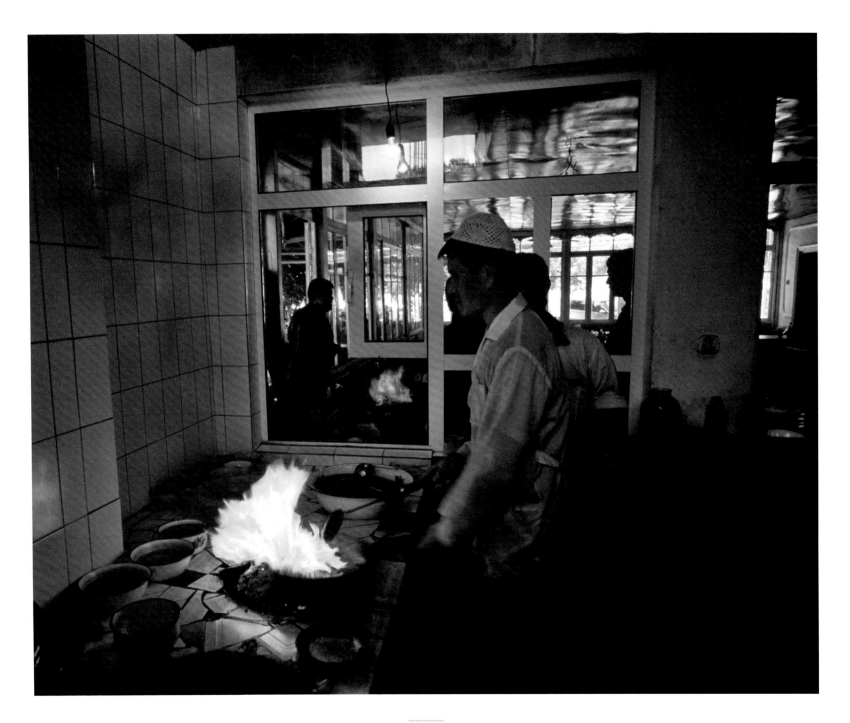

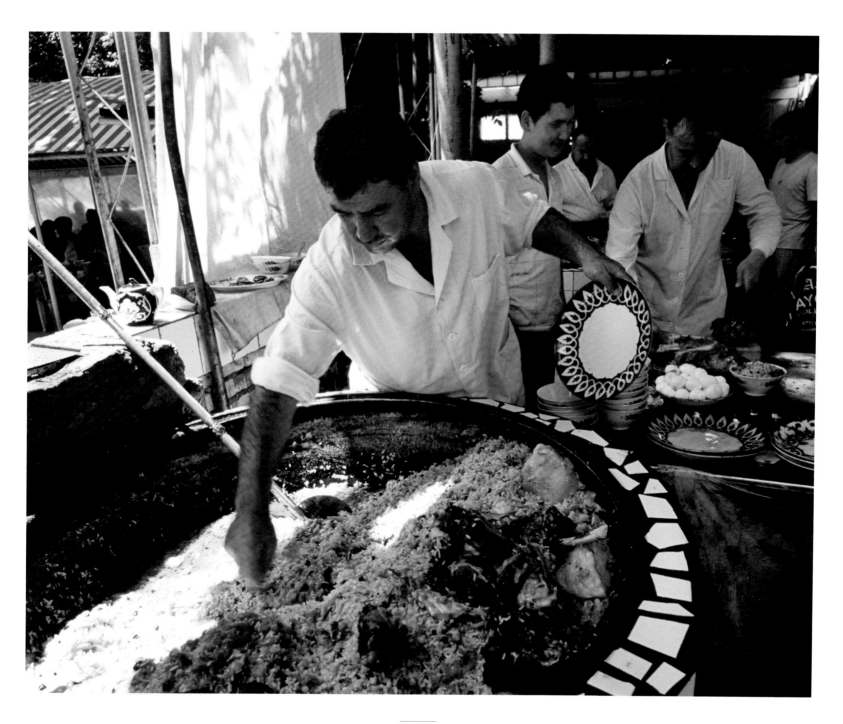

Previous pages, left
Playing with fire
Tashkent
Uzbekistan

Uyghurs from western
China have established
their own restaurants
wherever they have
settled. One of their
specialities is *laghman*
(literally 'pulled noodles')
– a meat-and-vegetable
soup served over freshly
made noodles. In this
photograph, Çağatay
shows Uyghur cooks at
a restaurant in Tashkent
preparing a sauce of meat
and tomato with star
anise over a fierce flame.

Previous pages, right
Mountains of *plov*
Tashkent
Uzbekistan

Plov (from the Persian
pilâv) is cooked in layers
and, when correctly done,
is beautifully aromatic and
melts in the mouth. This
rice dish is served almost
everywhere in Central Asia,
but the self-proclaimed
masters are the Uzbek
chefs, the *oshpaz*. Huge
plates are set with piles of
plov across Uzbekistan.
 Often cooked outdoors
in a steaming cauldron
(*kazan*), *plov* is basically
rice, onions and carrots
with either lamb or beef
and frequently quince,
dried apricots and raisins.
But for Uzbeks it is much
more than a mere dish –
it represents hospitality,
community and identity.

Teatime in Bukhara
Uzbekistan

Traditional *chaikhanas*
are often situated by
water. This photograph,
taken in Bukhara in 1993,
is probably of a teahouse
at the Lyab-i Hauz, one
of the few *hauz* (pools)
that have survived. Built
in the 17th century, the
pool is surrounded today
by ice-cream vendors and
modern-style cafés.
 Sitting on a *tapchan*,
the ubiquitous raised
platform used for eating
and reclining, these men
still wear a fabulous array
of traditional clothes,
with the *sella* (turban),
doppi (skullcap) and
quilted *chapan* (coat) all
represented. Two of the
men wear Russian fur
ushankas (the Central
Asian variant is a *telpak*).

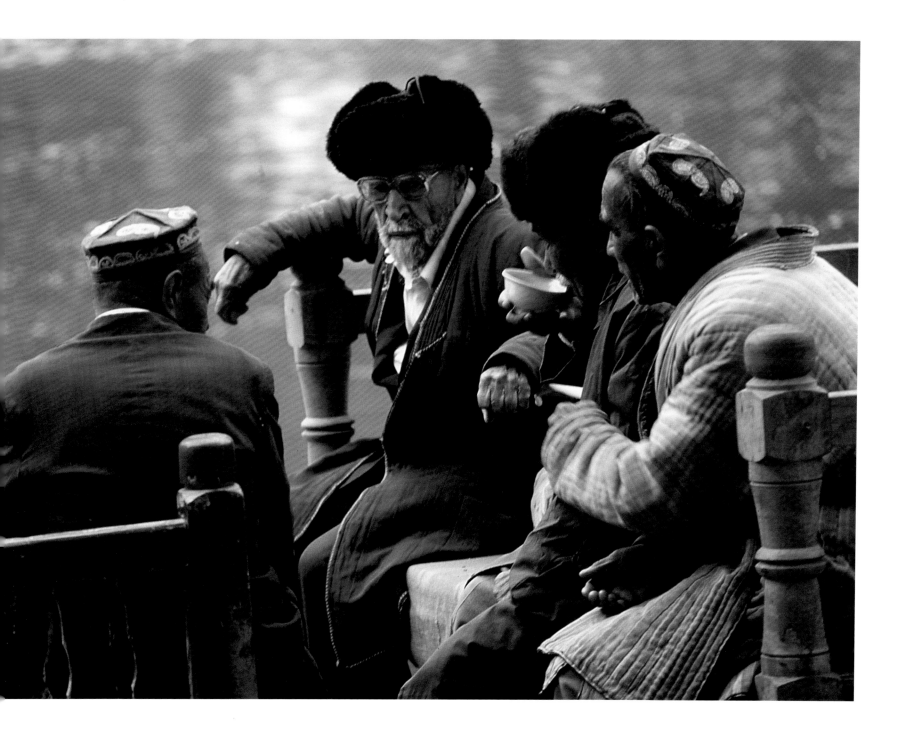

A winter's tale
Quba
Azerbaijan

Three hours north of
Baku, across the river
from the town of Quba,
is the village of Qırmızı
Qasaba. The name means
Red Town in Turkish,
though in this photograph
the buildings are more
ochre in colour.

At first glance Qırmızı
Qasaba looks much like
any other small town in
Azerbaijan, but it is home
to one of the most remote
Jewish communities in
the world and is believed
by some historians
to be the world's last
surviving *shtetl* (pre-
Holocaust Jewish village).
On the border of the
mountainous Russian
republic of Dagestan,
it was founded as a
haven for 'Mountain' or
'Caucasus' Jews in 1742 by
the Muslim emir of Quba.

The language of braids
Abakan
Khakassia, Russia

This woman in southern Siberia is dressed in a traditionally voluminous gown in the classic Khakassian manner, her scarf tied behind her head and colourful flowers embroidered on black shoulder panels.

Both social and spiritual significance was historically attached to hair, and braiding involved complex rituals. Multiple braids denoted a young unmarried woman. Two braids were for wives, three for older unmarried women, and a single braid was usually for a single mother. Believed to contain part of the soul and part of a clan's identity, any hair that was cut off had to be saved to protect the soul and was later placed in the grave.

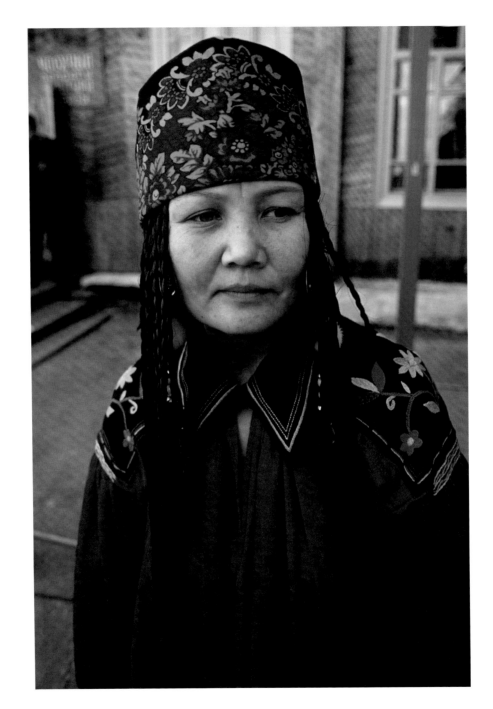

Costume drama
Karakalpakstan
Uzbekistan

Traditional Karakalpak jewellery is admired in the oasis cities of Uzbekistan for its elaborate open-work designs. Cutting a dramatic figure, this woman wears silver earrings from which hangs a chain of pendants that pass under her chin. A silver chain around her neck supports an impressive *khaykel* amulet set with carnelians.

Born of a belief in the protective properties of jewellery, such extravagance inevitably came to signal social status. This breathtaking ensemble was designed to appeal to both eye and ear, thanks to the melodious tinkle that accompanies the wearer everywhere she walks.

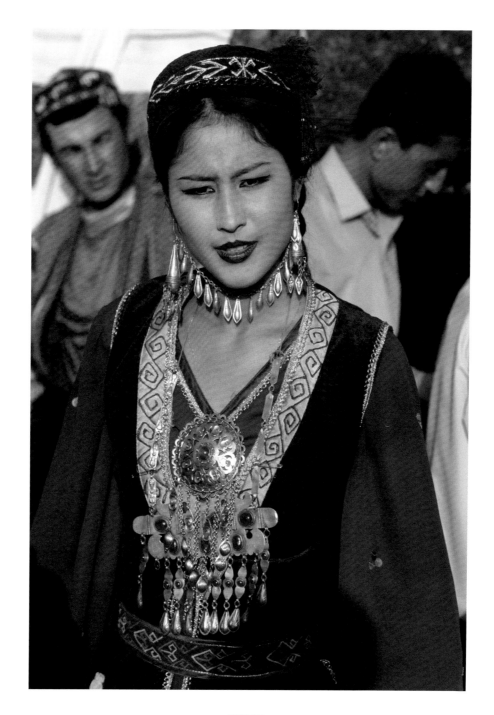

Right
Celebrating Women's Day
Tashkent
Uzbekistan

Uzbek girls gather as state awards are presented on March 8, International Women's Day. The girl in white holds up a plate with a portrait of the great poet Zulfiya Isroilova (1915–96). Uzbekistan's National Award for Women was set up in her name in 1999.

Left
Behind the scenes
Tashkent
Uzbekistan

Classical Uzbek dance usually features elaborate headdresses. There are three principal dance schools, named after their regions of origin, Fergana, Bukhara and Khorezm, each with its own aesthetic and choreography. Many small towns and villages also have their own unique folk dances.

These women wear ikat robes. Most ikat today is *atlas* (satin-weave fabric with silk warp and weft) or *khanatlas* (a denser silk satin weave). Ikat, the word used in the West for these characteristically Uzbek fabrics, is Indonesian. Uzbeks use the Persian word *abr*, meaning 'cloud'.

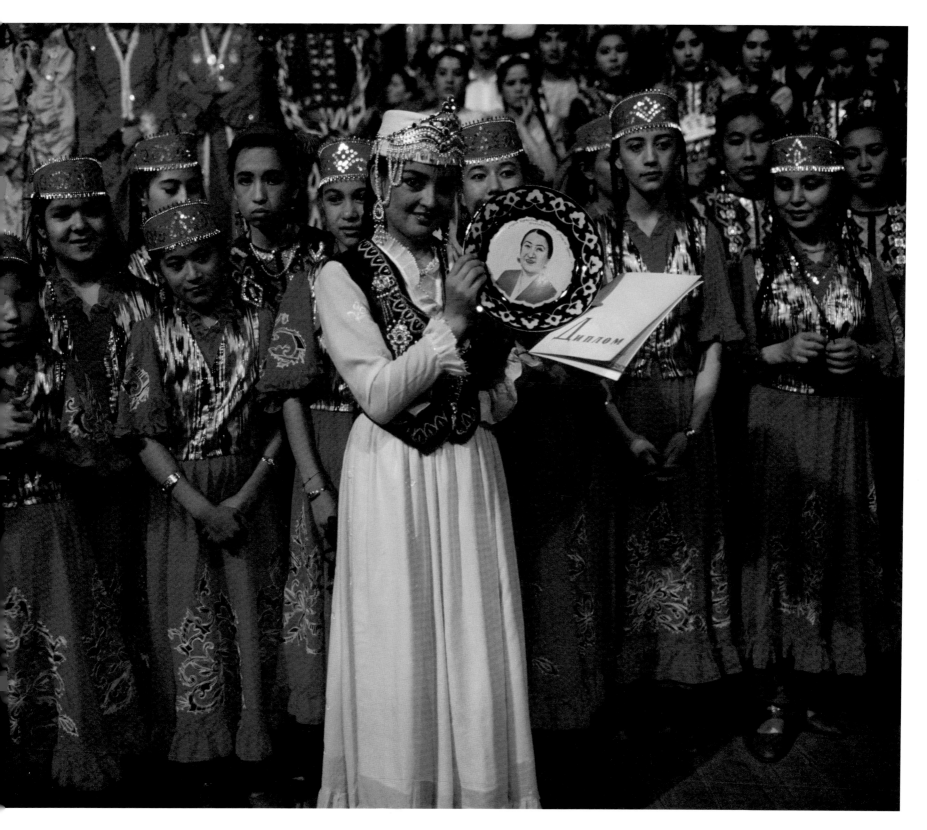

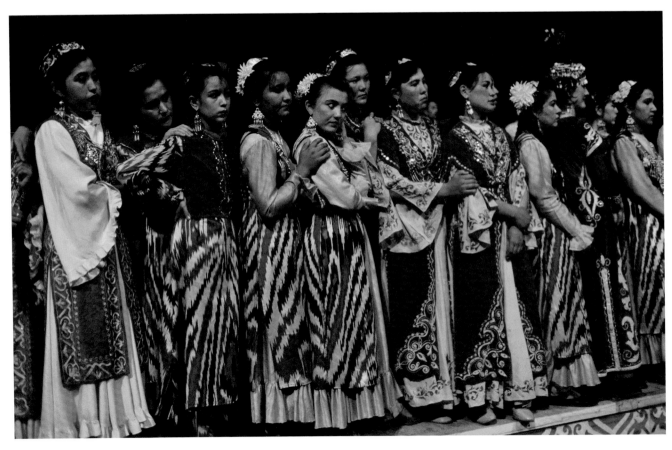

Rainbows of silk
Tashkent
Uzbekistan

Dancers in colourful ikat robes follow in the steps of Tamara Khanum (1906–91), a famous Uzbek dancer of Armenian origin, and the first woman in the country to perform publicly without a veil.

A museum in Tashkent is devoted to Tamara Khanum's life, her songs and her collection of costumes.

Dancers in diadems
Tashkent
Uzbekistan

These performers at the International Women's Day celebrations wear elaborate jewellery traditionally reserved for married Uzbek and Tajik women in settled communities. Their dazzling diadems are known as *tilla-kosh* (golden eyebrows), and their glass-bead necklaces as *zebi gardan*.

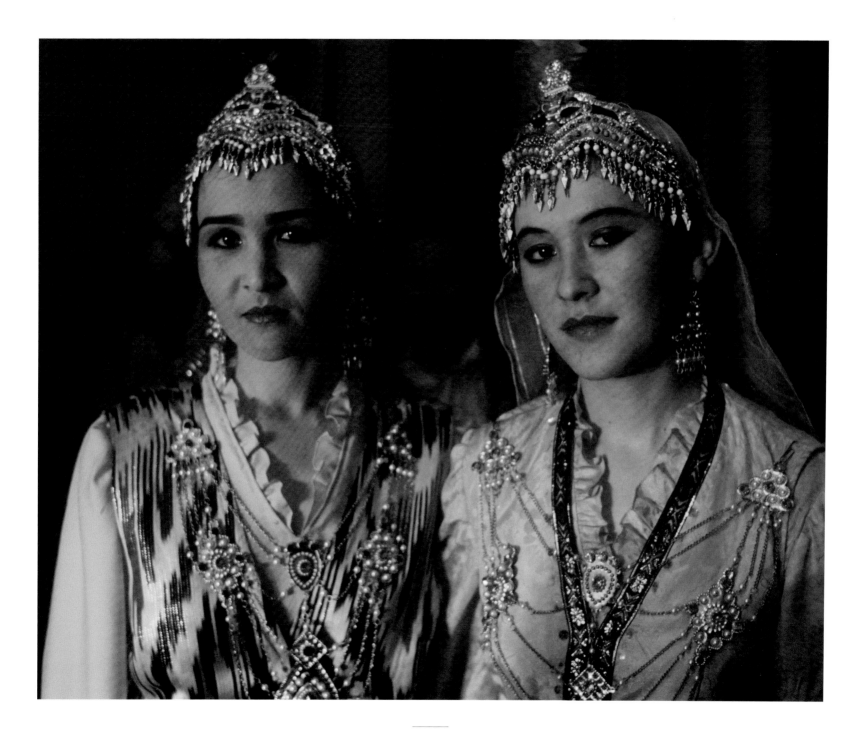

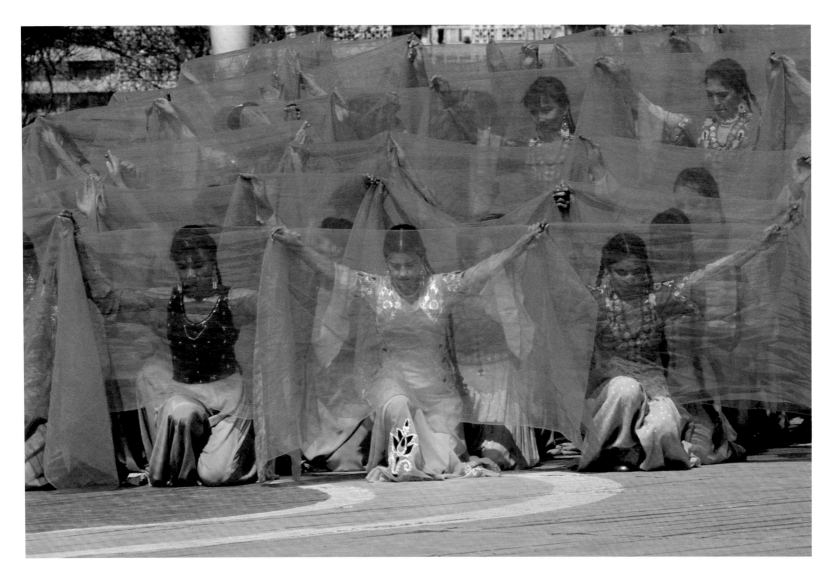

Away with the veil
Tashkent
Uzbekistan

These young dancers perform with striking gossamer-thin blue veils. Headscarves are mostly a matter of choice for women today in Uzbekistan, but it wasn't so long ago that Muslim women in this region, newly liberated by the Bolsheviks, were forced to remove their veils during the Hujum (assault) campaign, which culminated in mass veil-burning ceremonies on International Women's Day on March 8, 1927. Nobody regrets the loss of the *paranja*, the heavy black horsehair face veil that was mandatory in cities until the early 20th century. March 8, a national holiday, is now Mother's Day as well as Women's Day, and Uzbeks celebrate beauty, tenderness and feminine love in addition to women's cultural and political achievements.

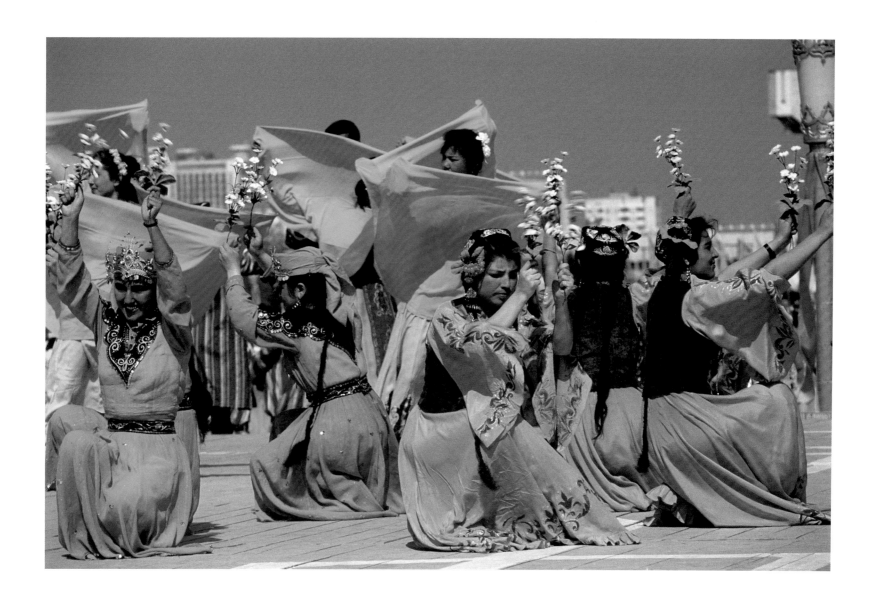

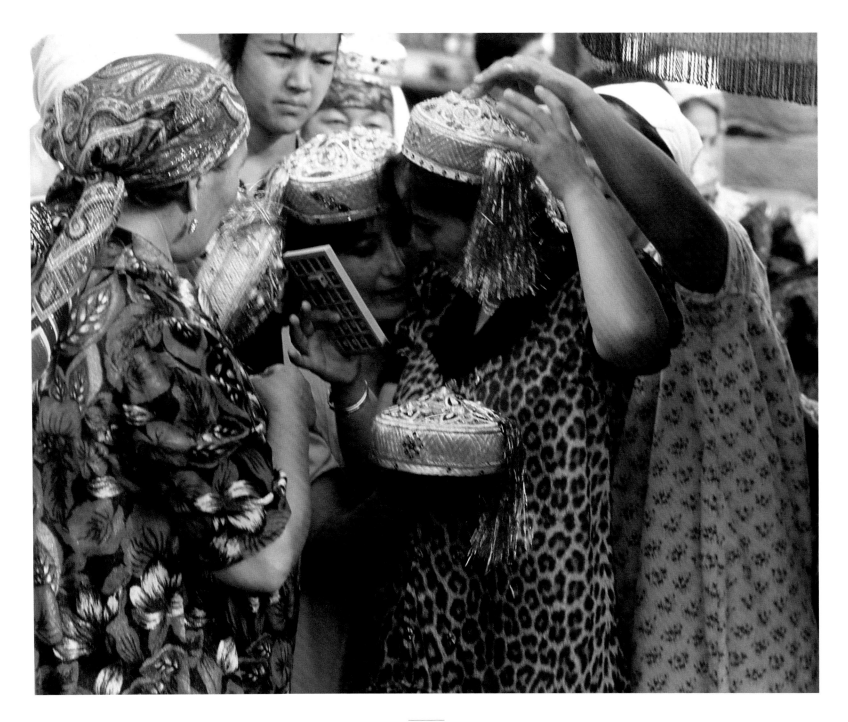

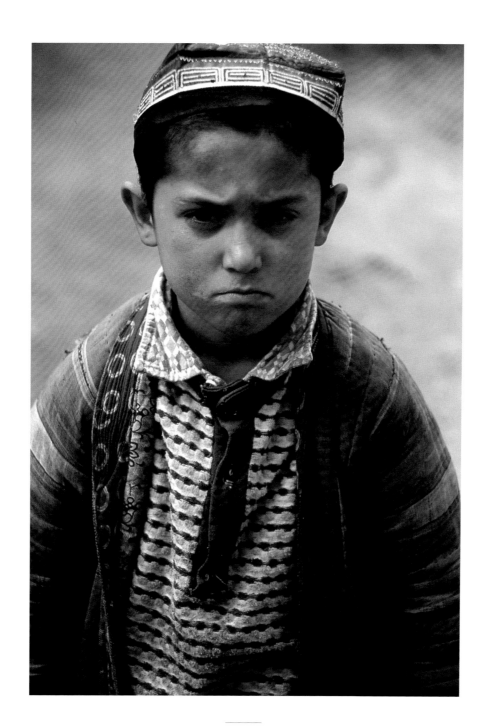

Wedding finery
Bukhara
Uzbekistan

Women in a Bukhara market compare hats embellished with gold embroidery (*kallapushi zarduzi*), which are worn as part of a wedding outfit in Bukhara. The young woman in the leopard-skin dress is perhaps a bride-to-be.

A stern young man
Uzbekistan

This disgruntled Uzbek boy wears a traditional quilted stripy *chapan* and a *doppi* skullcap.

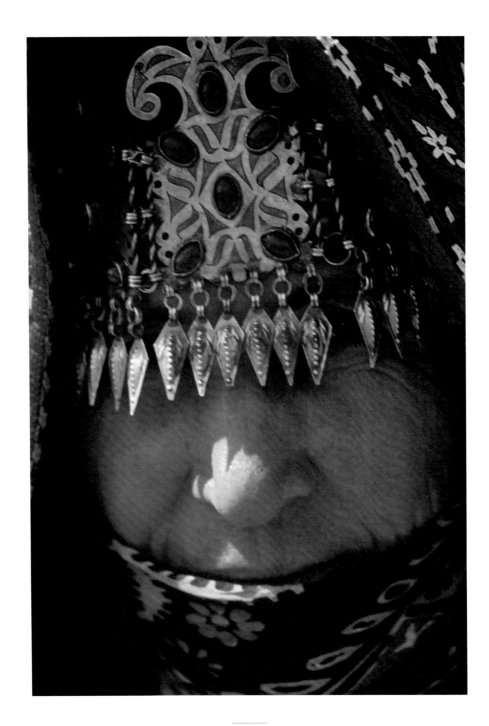

Jewels of the
Karakum Desert
Turkmenistan

The Turkmen, perhaps
in response to their
harsh, arid environment,
are noted for their bold
jewellery and the vibrant
reds, purples and yellows
of their costumes. The
ceremonial headdress
worn by this Turkmen
woman is adorned with
a monumental brass and
silver amulet set with
carnelian stones; the
embossed silver pendants
act as a partial veil. Silver
is considered to have
cleansing and magical
properties, while carnelian
brings the wearer health,
peace and prosperity.

Private lives
Uzbekistan

In Uzbekistan, much
of life happens behind
high walls and in internal
courtyards (*hayats*),
especially in traditional
neighbourhoods
(*makhallas*). Here,
Çağatay shows us
glimpses of this life: a
sliver of floral dress, an
old woman's slippered
foot; a mother and baby
looking out, almost
inviting the viewer in.
Private and public spaces
are artfully juxtaposed.

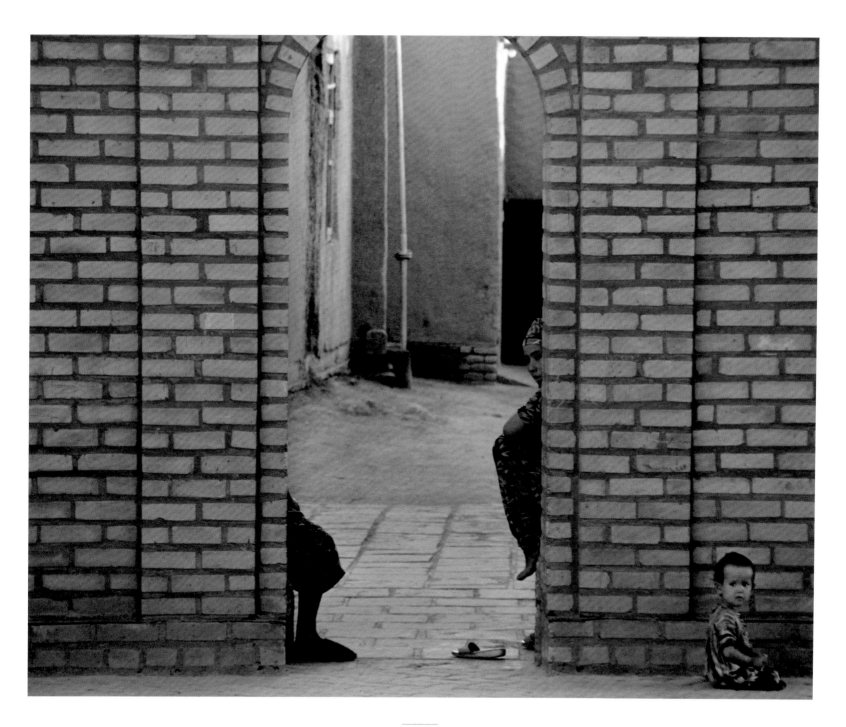

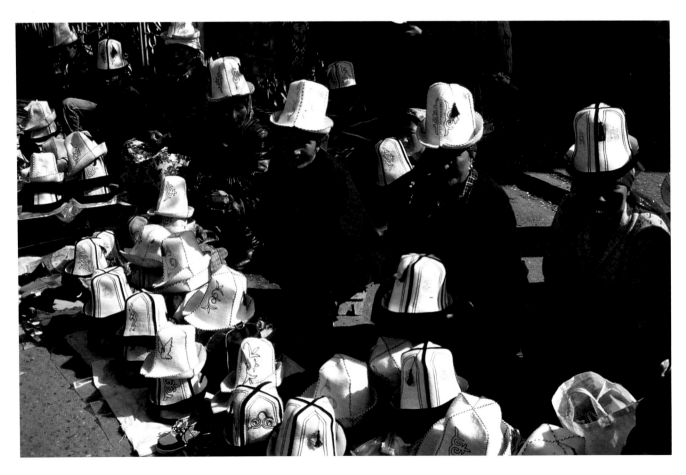

The white kalpak
Kyrgyzstan

Seen here for sale in a street market is the national headgear of the Kyrgyz, the *ak kalpak*, so revered that it now enjoys its own public holiday on March 5. This tall, four-sided white felt hat made an early appearance in Kyrgyz culture, being mentioned in the *Epic of Manas*, a 500,000-line poem said to be a thousand years old. This 'Iliad of the steppes' describes the *ak kalpak* as being as white as the peaks of the Tien Shan. It is practical too: warm in winter but cool in summer.

Opposite
Fabric of life
Bukhara
Uzbekistan

An Uzbek trader in Bukhara, surrounded by fabrics of every colour. Çağatay shows the sheer range of Uzbek textiles while bringing in the everyday with the woman's lunchtime bowl and spoon. The most luxurious fabric, silk-velvet *baghmal*, arrived early in the 19th century and is still worn today. Rich, deep colours such as purple, orange and brown are ever popular.

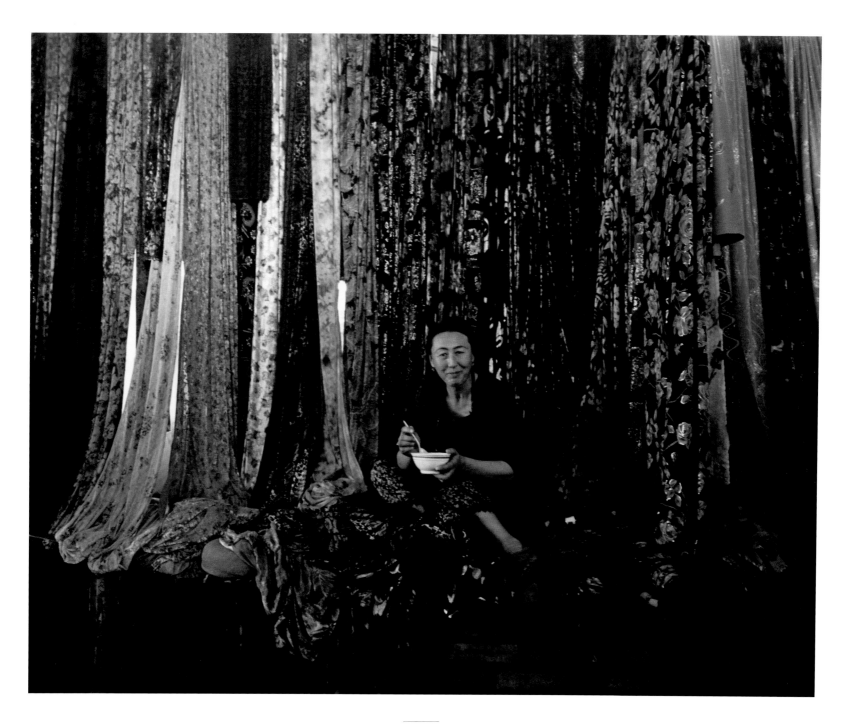

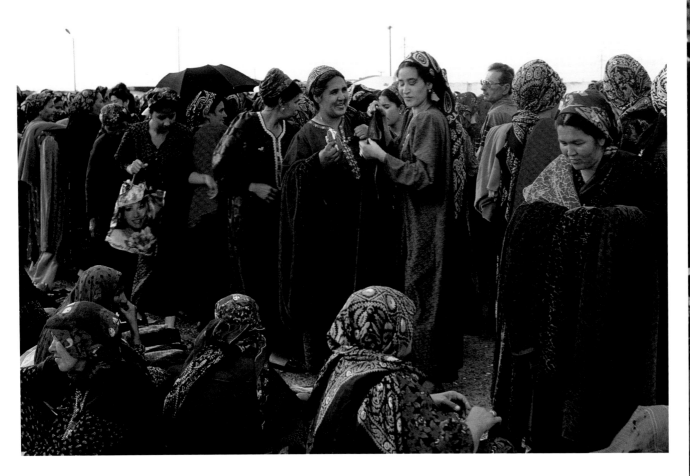

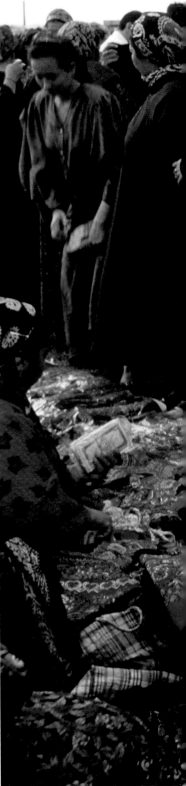

Above and right
A woman's realm
Ashgabat
Turkmenistan

Çağatay photographed
the old Tolkuchka Bazaar,
dominated by women, in
the 1990s. Trade was
brisk in this desert
market on the outskirts
of Ashgabat, capital of
Turkmenistan. Standing
on the southern edge
of the Karakum (Black
Sands) Desert, the market
was a kaleidoscope of
colours, shades and
patterns. Russian-style
florals prevailed in the
loose, brilliantly coloured
ankle-length kaftans;
elsewhere you could
also see more traditional
motifs, as well as gold
thread and tassels.
In 2010 this legendary
market was relocated to
the Altyn Asyr Oriental
Bazaar, a vast hangar-
style affair, which may
offer protection from the
fierce sun but lacks the
old chaotic charm.

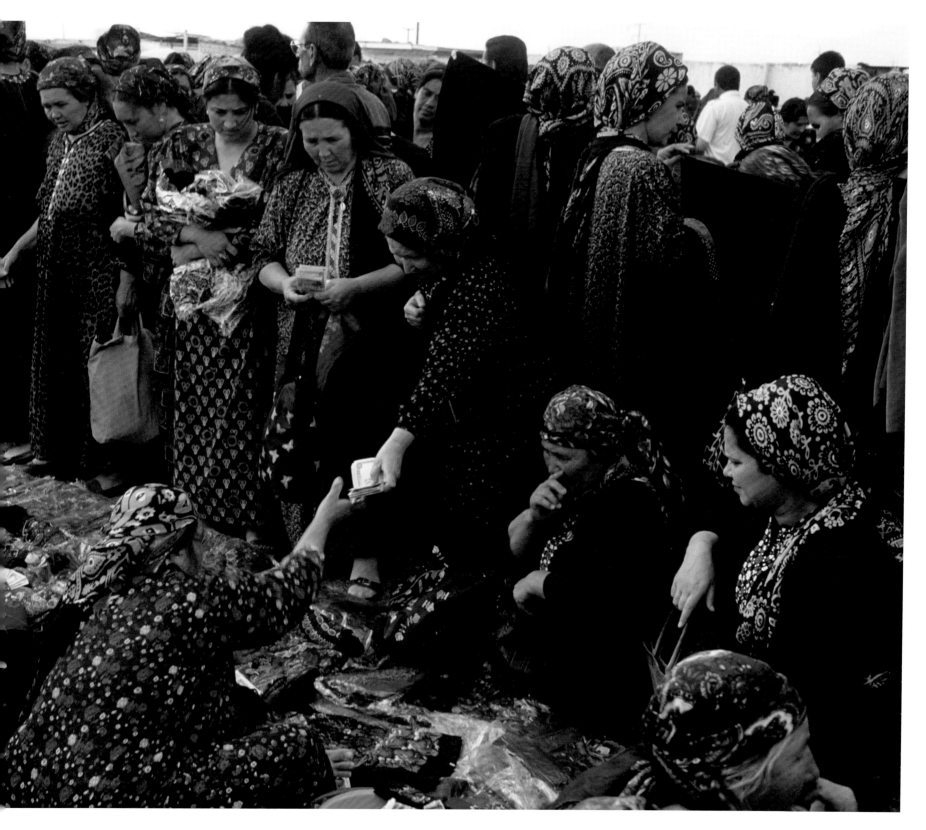

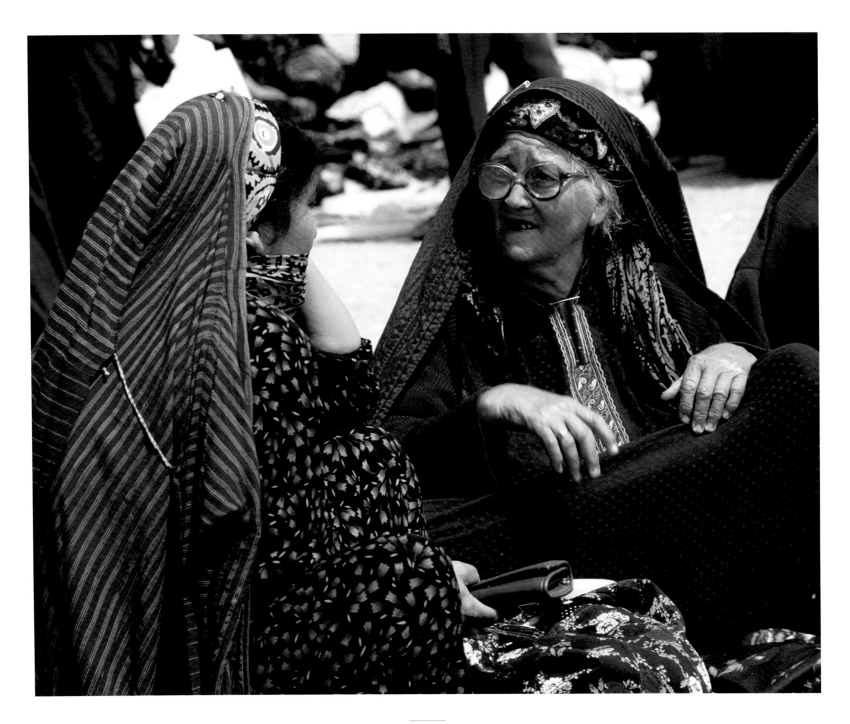

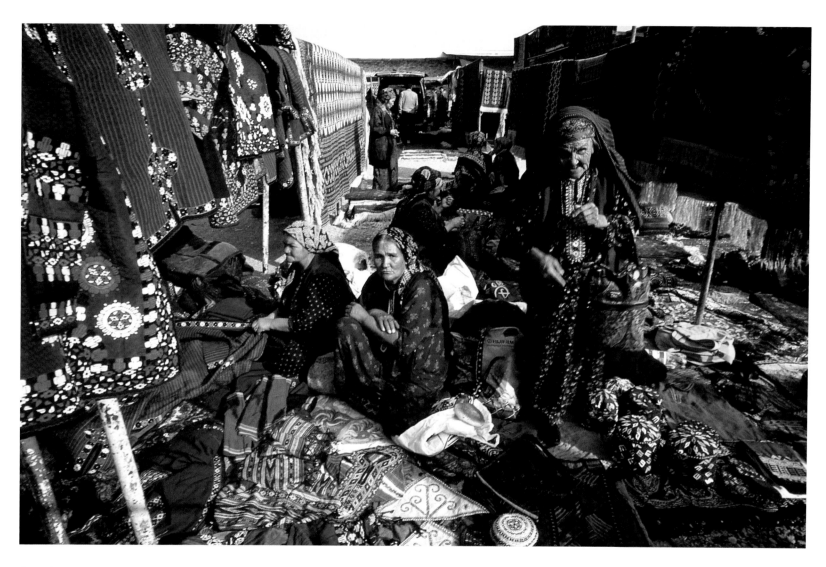

Opposite
A love of red
Ashgabat
Turkmenistan

Desert women selling fabrics in Ashgabat. In Turkmenistan, which is still hard to enter, most women wear national dress, often made from new fabrics in bright colours and exuberant patterns. The young woman seen here has a *chapan* on her head (a man's coat, in a rich red with narrow stripes) to protect her from the burning sun. Red, a colour beloved by Turkmen, is traditionally made with madder and cochineal.

Material wealth
Ashgabat
Turkmenistan

Women surrounded by Turkmen carpets and traditional robes, including red indoor coats (*kurte*) and outdoor coats (*chyrpy*). One of the women handles the typical striped red *chapan*. On the ground are triangular amulets and flat-topped caps, both embroidered with symbols to protect the wearer against troubles, illness, jinxes – and above all the evil eye.

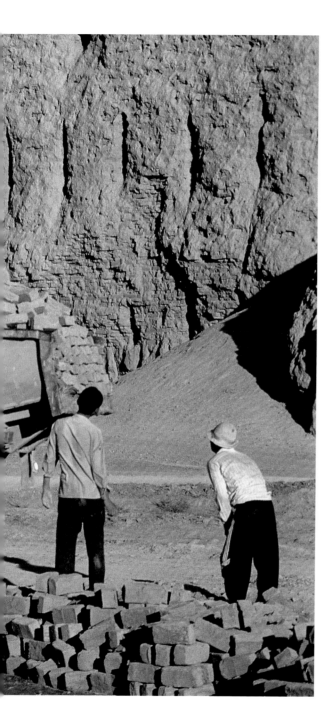

Glorious mud
Uzbekistan

Mud-brick walls,
often decorated with
ceramic tiles, dominate
major monuments in
Uzbekistan's ancient
cities. Today the tradition
continues in newer cities
such as Navoi. Desert-
coloured, the bricks
change hue depending
on the time of day.

Overleaf
Walls of power
Bukhara
Uzbekistan

A man walks past the
six-metre-thick walls of
the Ark of Bukhara. A
mud-brick fortress, the
Ark was in use from the
5th century until it was
bombed in 1920 by the
Bolshevik commander
Mikhail Frunze.

Inside are museums
and the remains of royal
quarters, offices, stables
and the dungeons that
once held the Italian
watchmaker Giovanni
Orlando. Commissioned
to make a clock by
Nasrullah Khan, Emir of
Bukhara from 1827 to
1860, Orlando was swiftly
beheaded when the
grand clock stopped.

More famously, it
was here in 1842 that,
in the Great Game (the
struggle between Britain
and Russia for influence
in Central Asia), Arthur
Conolly and Charles
Stoddart fell foul of
Nasrullah and were
also beheaded.

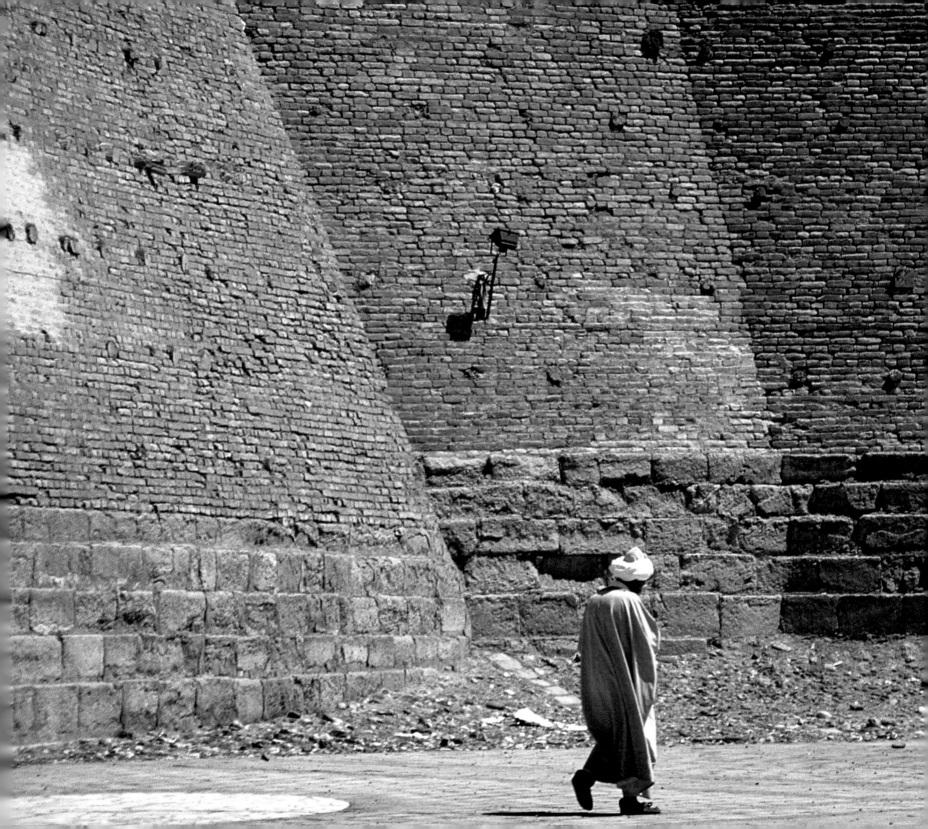

Tower of strength
Bukhara
Uzbekistan

The Kalyan Minaret is the symbol of Bukhara, a city beloved of historians and travellers alike. As the local saying goes, 'In all other parts of the world light descends upon earth. From holy Samarkand and Bukhara, it ascends.'

Built in 1127 for the Karakhanid ruler Arslan Khan, the minaret served as a watchtower in times of war. So impressive was its 52-metre height that Genghis Khan spared it from destruction. It also survived Bolshevik shelling in 1920, though one side of the lantern had to be rebuilt.

Despite the textured beauty of its fretwork shaft, it is perhaps best known as the 'tower of death', since condemned criminals were tied up in sacks and hurled from the top on market days, with town criers calling on crowds to witness the spectacle.

The last emir's baths
Bukhara
Uzbekistan

A tranche of the huge, honey-hued Kalyan Minaret, revealing the complex patterns of the 23 bands of brickwork. Calligraphic tiles, with angular Kufic script threaded through the lower line of Thuluth, have replaced the original stucco inscription. To the right are the three domed chambers of a later hammam attached to an 18th-century medrese, lit from high above by cupolas with screened windows. The complex is named after the large, colourful Said Mir Mohammed Alim Khan (1880–1944), last emir of Bukhara, who was forced to flee by the Bolsheviks in 1920.

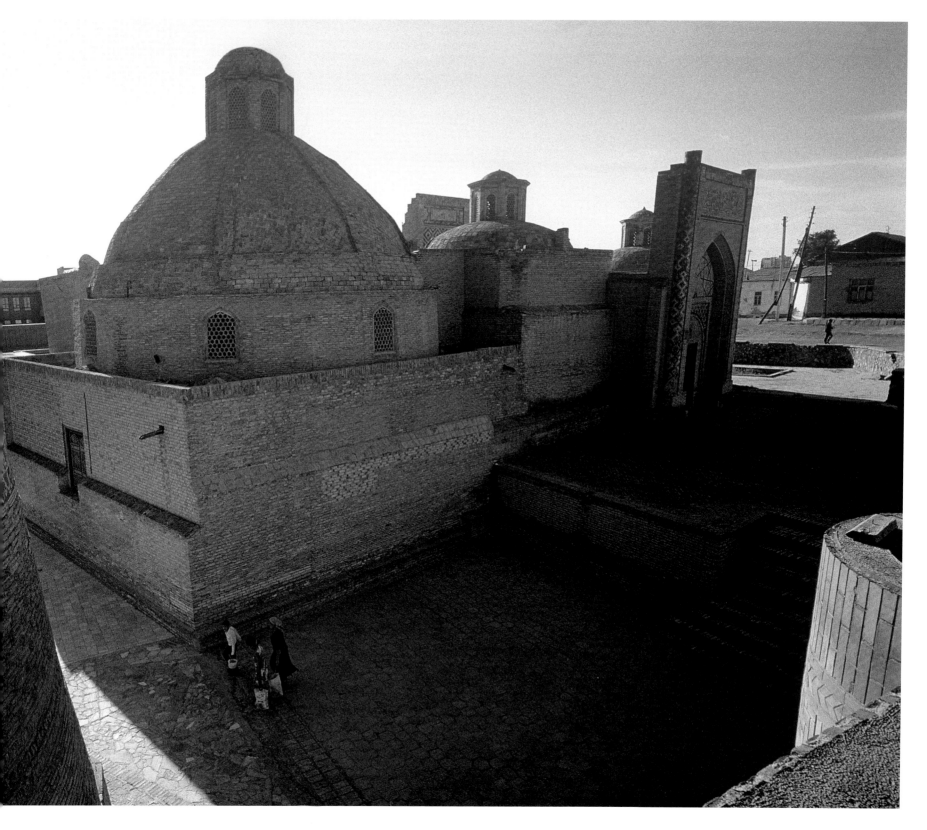

A blessed life
Kunya-Urgench
Turkmenistan

Pilgrims in Kunya-Urgench, northwest Turkmenistan, seek blessings at the tomb of the Sufi saint Najm al-din Kubra. The mystic died In 1221 fighting hand-to-hand with the forces of Genghis Khan, who destroyed what was then the capital of the Khwarazmian Empire, a vital trading centre on the Amu Darya river.

This mausoleum dates from a later golden age, the early 14th century, as do the striking blue-and-white tiles of its portal. At the time, the traveller Ibn Battuta called Kunya-Urgench 'the largest, greatest, most beautiful and most important city of the Turks'. But in 1388 it fell to Timur, who razed it to the ground and planted barley over its ruins. The city's ultimate demise came in the 16th century, when the Amu Darya suddenly changed its course.

The final mausoleum
Kunya-Urgench
Turkmenistan

Facing the tomb of the
Sufi saint Najm al-din
Kubra (previous pages),
this mausoleum was the
city's swansong. Intended
to be clad with tiles, it
was built in the late 16th
century by Sultan Ali,
the last ruler of Kunya-
Urgench. The protrusions
on the dome may have
been temporary footholds
to enable craftsmen to
work on the decoration.

 To this day, a cluster
of monuments dating
from the 11th to the
16th centuries, including
fortresses, mausoleums
and a towering
minaret, continue to
attract pilgrims to this
abandoned city.

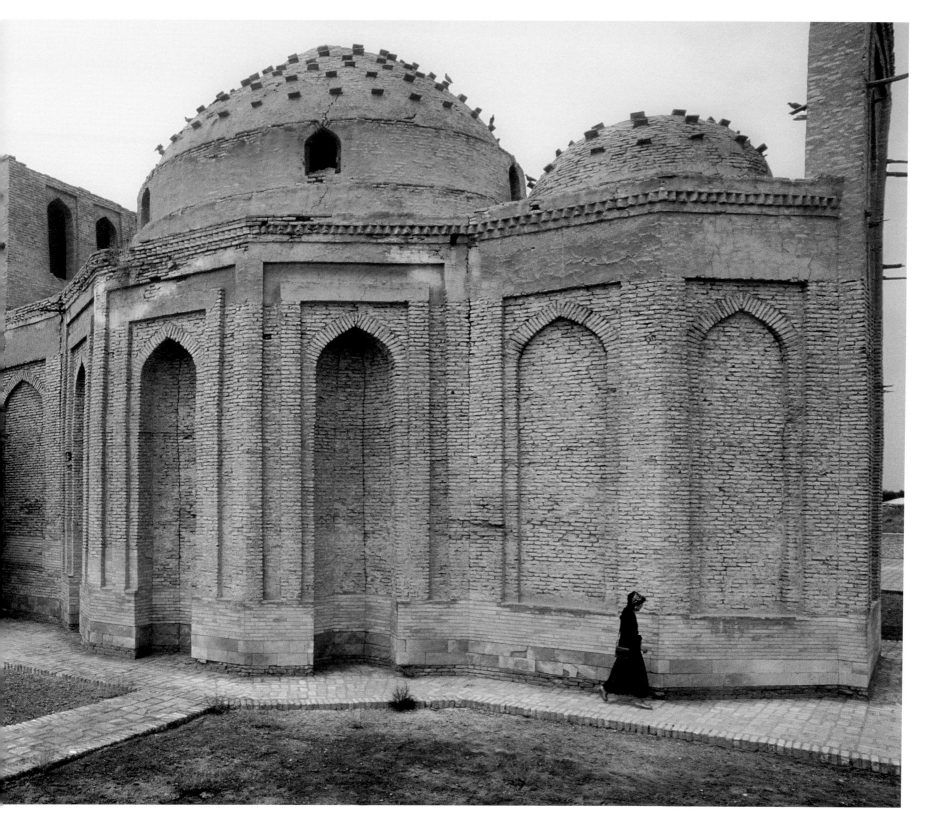

Pilgrims' progress
Kunya-Urgench
Turkmenistan

A woman prays with her children at the foot of the Kutluğ-Timur Minaret in Kunya-Urgench, where pilgrims walk round in an anticlockwise direction. The tallest minaret in Central Asia, this steeply tapering monument measures 12 metres in diameter at its base and just two at the top, soaring to a height of 62 metres. A lantern on top served to guide distant caravans at night. The original tower dates from 1011, but was restored or possibly rebuilt by Kutluğ-Timur (1321–36), whose name it still bears.

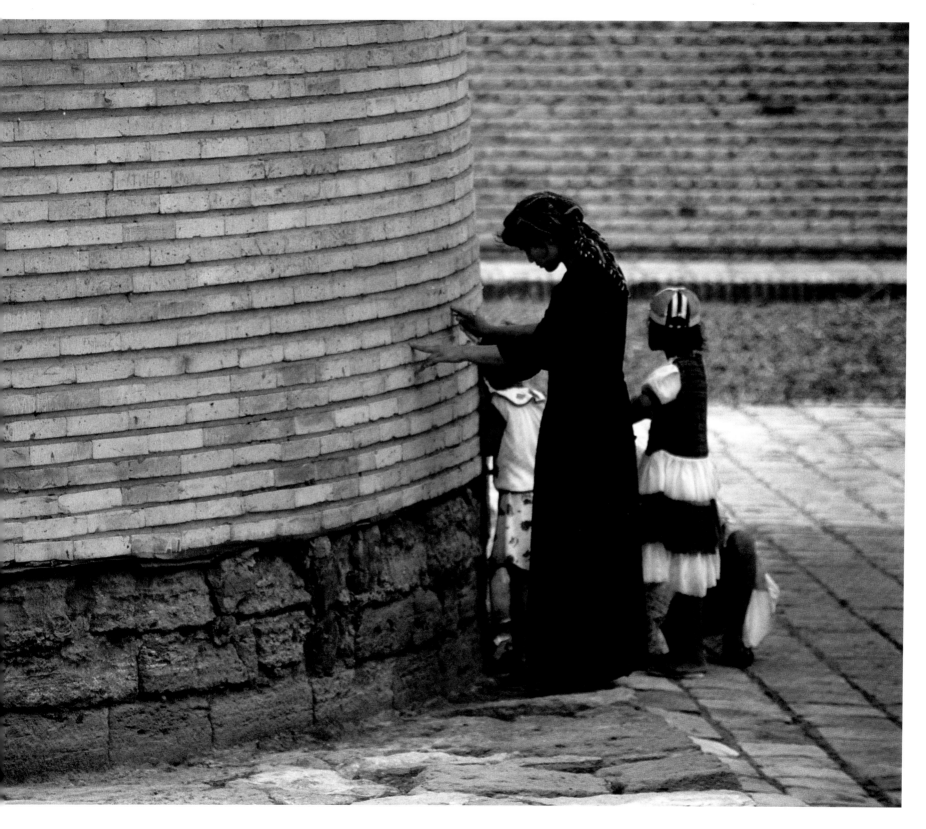

The eternal avenue
Samarkand
Uzbekistan

Uzbekistan's second city, Samarkand, was the capital under Timur in the 14th century. An intellectual and religious centre, it was greatly beautified by talented masons, painters, weavers, silversmiths and tile-makers brought from the lands Timur conquered across Persia, India and Asia Minor.

While the city's most famous sight today is the Registan, the grand public square at the centre of the city, the most impressive survivor is the Shah-i Zinda, an avenue of mausoleums from the 14th and 15th centuries (pictured here before full restoration).

It is a moving and memorable experience to wander alongside local pilgrims past the tombs of Timur's wives and the grave of Qusam ibn-Abbas, a cousin of the Prophet Mohammed.

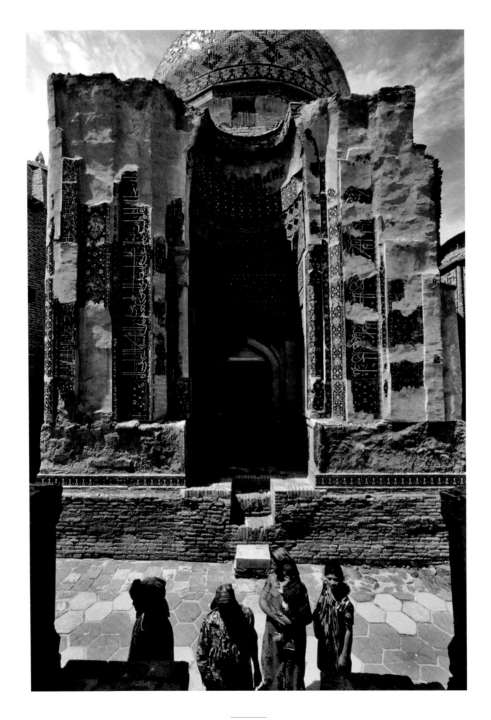

The Lion's Gate Medrese
Samarkand
Uzbekistan

This is the courtyard of the striking Sher Dar (Lion's Gate) Medrese on Samarkand's Registan Square, instantly recognisable from the outside by the tiger-like lions at the entrance portal, which famously disregard Islamic prohibitions against depicting live animals.

The medrese was built in the early 17th century, taking as its model the famous nearby 15th-century medrese of Timur's grandson Ulugh Beg, who is still celebrated as a mathematician and astronomer. The more florid tilework of the Lion's Gate Medrese departs from Ulugh Beg's severely geometric, astronomically inspired tile designs.

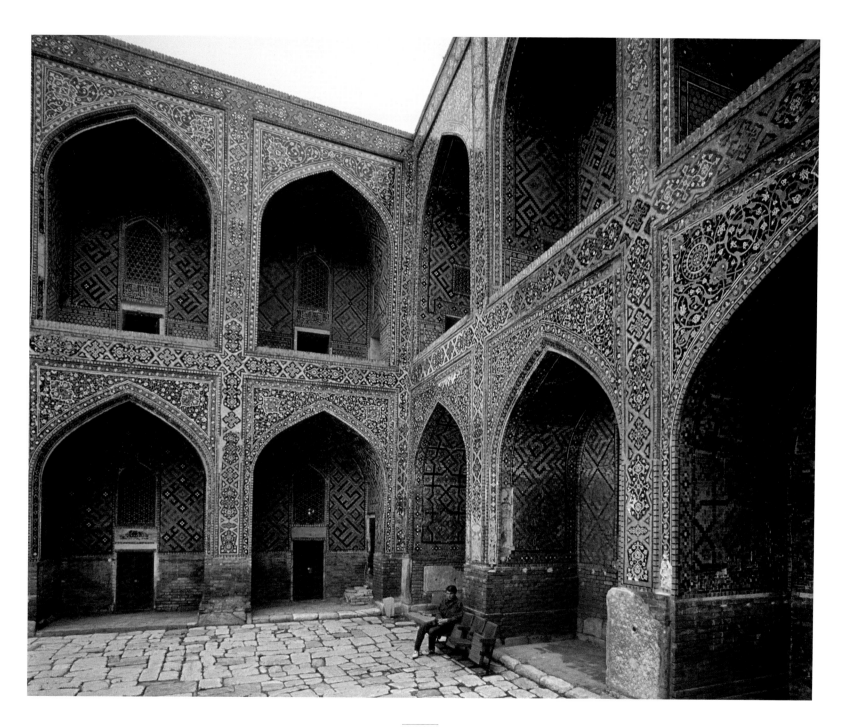

Heart of the fortress
Khiva
Uzbekistan

Khiva, once capital of the Khanate of Khiva, was long denigrated as a city of slave traders and sheep thieves. Pacified by the Russians towards the end of the 19th century, it is now a museum city popular with tourists.

The medieval walled Inner City, or Ichan Kala, is protected by ramparts that stretch a mile and a half; some sections date to the 5th century. Inside the ramparts, a maze of mud walls shields mosques, medreses and mausoleums. Much of what we now see was added by 18th- and 19th-century khans.

Wooden columns with intricately carved capitals surround the small early-19th-century Ak Mesjid (White Mosque). Their delicate proportions contrast with the massive mud-brick medreses that line the main street. The names of the master craftsmen who carved the columns are inscribed on the mosque door with the years 1838 and 1842.

Visible at the far end is the Kalta Minaret, a Khiva landmark. Intended to be 70 metres high, it was left unfinished in 1855 but clad in typical blue-green tiles.

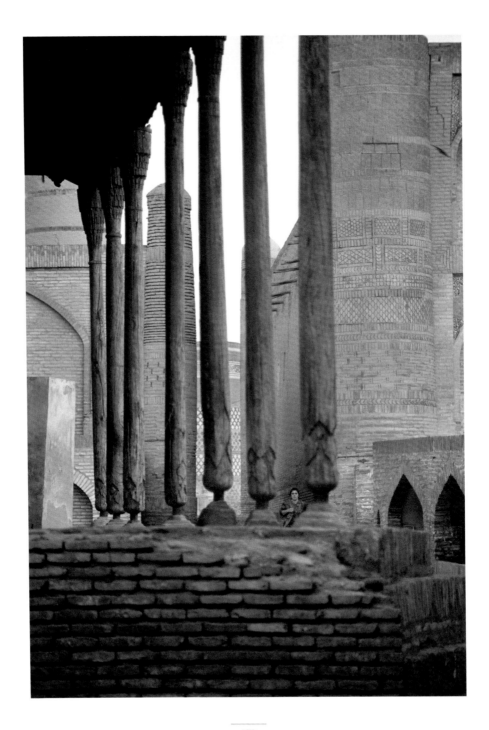

A forest of columns
Khiva
Uzbekistan

The Juma (Friday) Mosque seen here was built in the late 18th century, but some of the 212 carved columns of black elm are 10th-century, recycled from elsewhere.

The woodcarving tradition is enjoying a small revival in Khiva. Artisans can be seen carving elm, walnut and apricot wood into columns, doors and beds in the city's backstreets. Former medreses are now craft centres selling beautifully carved pencil boxes, bookstands and walking sticks as souvenirs.

Beyond the ramparts is the lesser-visited Dishon Kala (Outer City), the old merchant suburbs, a mixture of medieval and Soviet buildings.

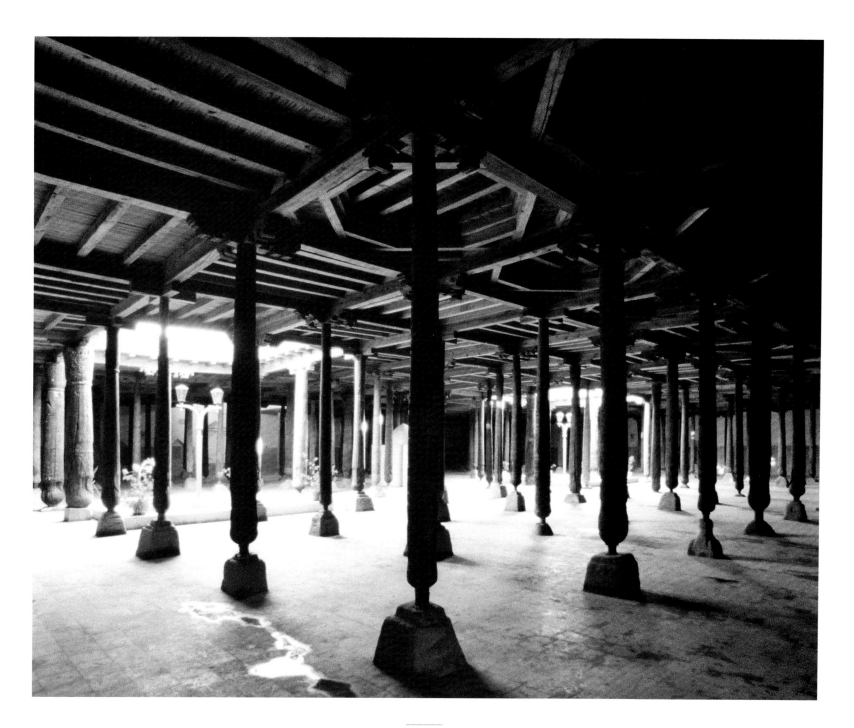

In memoriam
Tashkent
Uzbekistan

Honouring more recent
history is a colonnade
of carved columns in
Tashkent's Independence
Square. Known as 'Glory
and Memory Alley', it
is a memorial to Uzbek
soldiers who died in
the Second World War.
Lining the walls are giant
'Memory Books' listing
the names of those who
gave their lives.

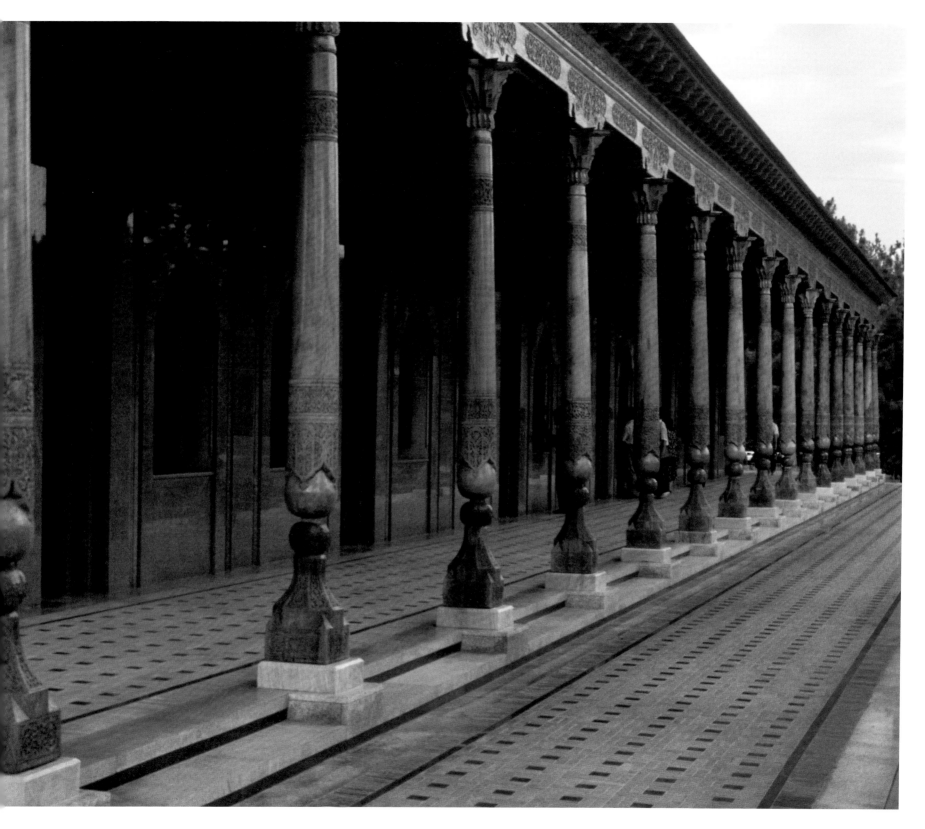

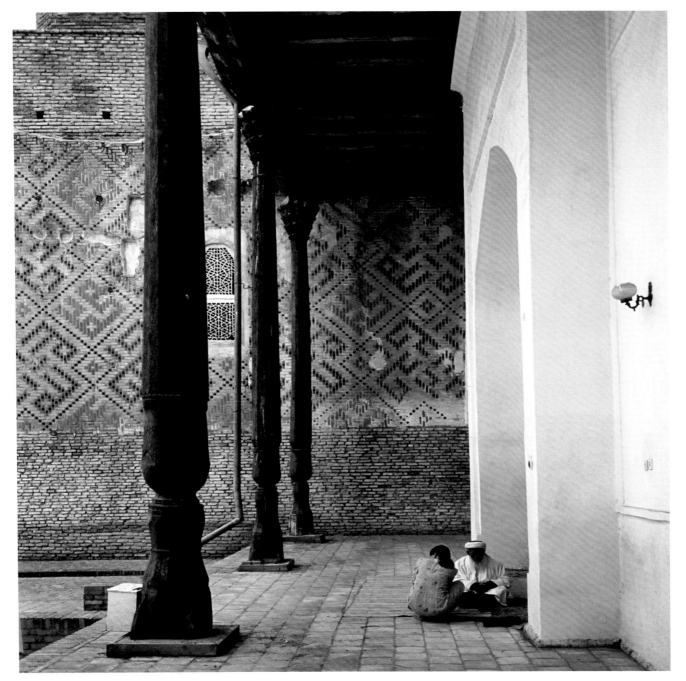

Timur's legacy
Shakhrisabz
Uzbekistan

The Dâr us-Siyâdat memorial complex was intended for the whole Timurid dynasty. It was founded after the untimely death in 1376 of Timur's eldest son, Jahangir, at the age of 22, which left the conqueror disconsolate. His son's body was moved from Samarkand to Shakhrisabz, historical homeland of his forefathers. According to a court chronicler, Timur ordered that 'the building of *makbarats* [burial vaults] and new *khazira* [courts] should be completed for the *emir-zade* Jahangir and other descendants and nobles'. On the walls are geometric renderings of 'Allah' in bands of glazed brick, a classic technique known as *banna'i*.

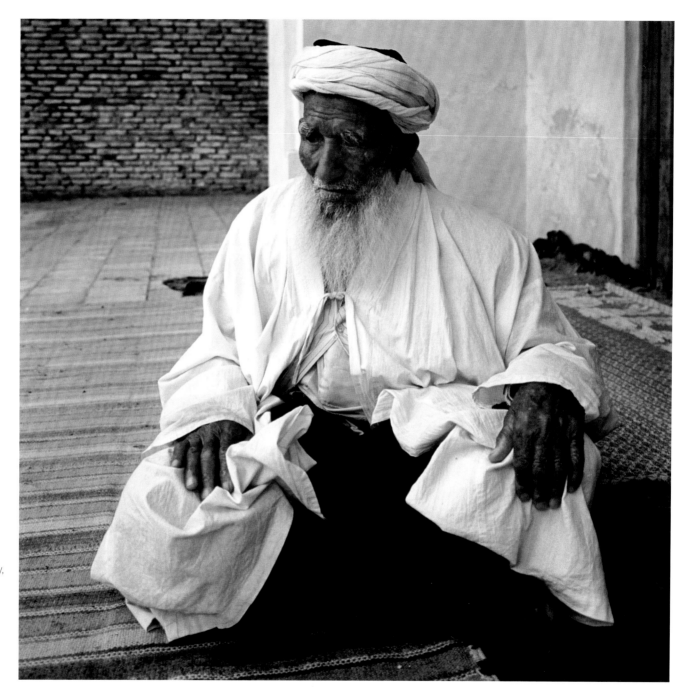

An elder of Kesh
Shakhrisabz
Uzbekistan

A venerable turbaned
man sits in the doorway
to a crypt behind the
Dâr us-Siyâdat complex.
Timur was born in the city,
previously known as
Kesh, in 1336, and the
crypt was designed
to be the conqueror's
burial place. Although
he was actually buried in
Samarkand, pilgrims still
make their way here.

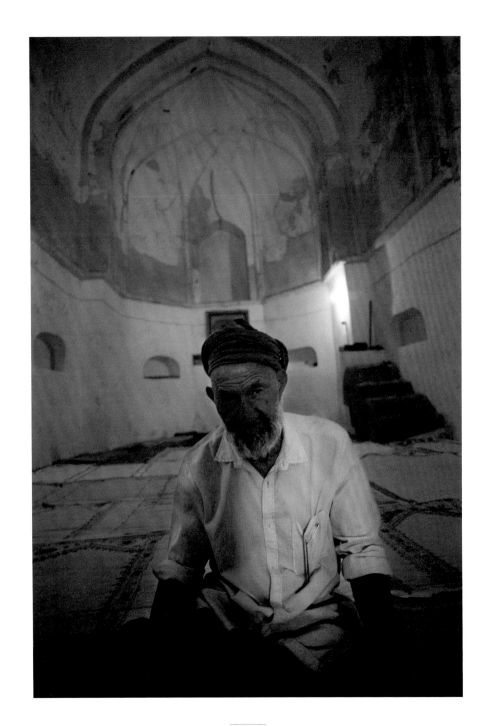

The imam
Uzbekistan

Çağatay does not specify
where this unpublished
portrait of an imam was
taken. The mosque is
simple but beautiful,
with its elegant arched
recess containing the
mihrab and its patchwork
of modest rugs.

Poetic pillars
Samarkand
Uzbekistan

A young woman in a
bright floral dress leans
against one of the carved
wooden columns used
in the restoration of the
Shah-i Zinda necropolis.
The evocative weathered
originals lie on the floor.
Simple plasterwork
arches line the walls of
this loggia overlooking
the entrance to the
necropolis, where pilgrims
rest before entering.

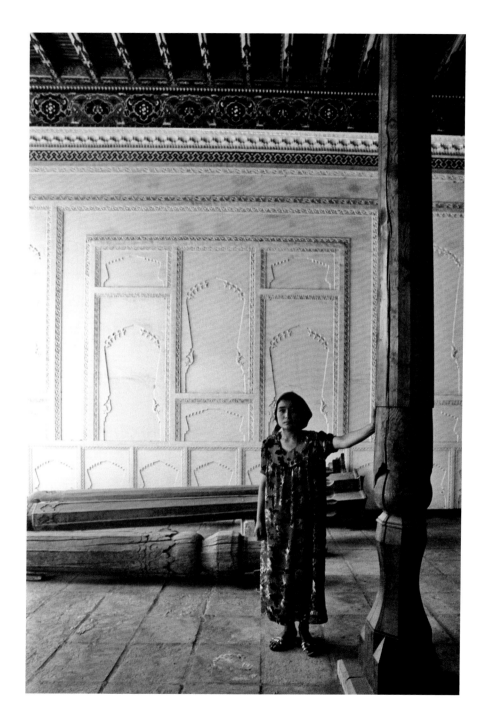

The Karakalpak
'little red dress'
Nukus
Uzbekistan

Under the emirs, textile
workshops were set up in
the 17th century close to
the palaces of Bukhara,
Khiva and Kokand, to
create the fabulous fabrics
the country is still known
for. Even remote peoples,
such as the Karakalpaks
on the shore of the Aral
Sea, dressed in fine clothes.

This woman wears a
sumptuous ikat gown
with a richly embroidered
felted cowl known as a
kızıl kiymeshek (little red
dress). Traditionally part of
a wedding dowry, the cowl
would be stitched by the
bride-to-be, who began
its creation with a prayer.

The origins of the
turquoise-studded
headdress, the dowry's
most precious element,
can be traced to the battle
helmets of ancient female
warriors – Turkic tribes
were mostly matriarchal.

Çağatay's photograph
was taken in Nukus, at the
Karakalpakstan State
Museum. The artist Igor
Savitsky housed his
ethnographical finds here
next to his paintings of
Russian artists banished
by Stalin – the largest
avant-garde art collection
outside St Petersburg.

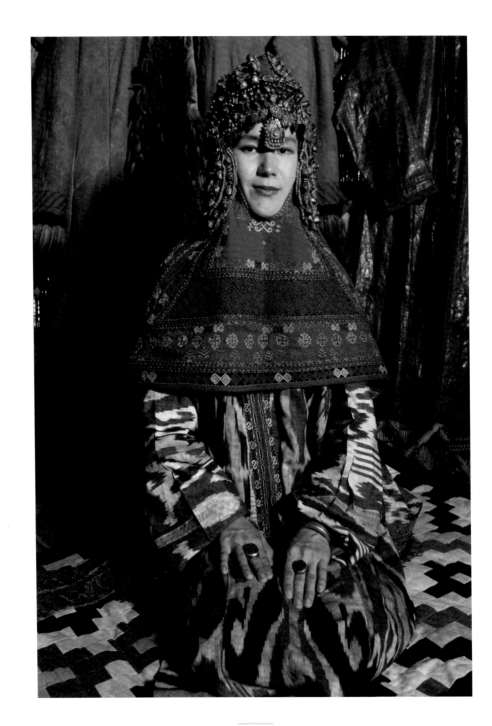

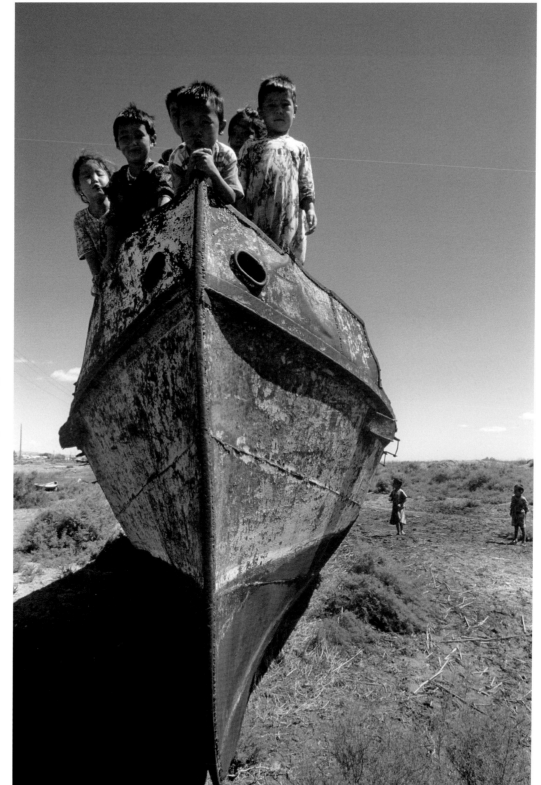

Tragedy of the Aral Sea
Moynaq
Uzbekistan

A beached boat in Moynaq, once a thriving fishing port on what was the Aral Sea, the world's fourth-largest lake, until Soviet planners caused the world's worst man-made ecological disaster by draining the rivers that fed the Aral Sea to irrigate notoriously thirsty cotton fields. The result – still very much in evidence – is a wrecked ecology, frequent salt-dust storms and devastatingly hard lives. Today, Uzbekistan shares what is left of the sea with Kazakhstan.

Some good news, however: there has been a modest return to fishing in Kazakhstan thanks to the eight-mile Kok-Aral Dam, which splits the North Aral Sea from the South. A few cautious fishermen have been able to return to their boats to catch carp, roach and zander (pikeperch).

Overleaf
High and dry
Moynaq
Uzbekistan

A fleet of Soviet iron trawlers rusts away on what was once the shore of the Aral Sea. The hammer-and-sickle on the funnel recalls a forgotten era.

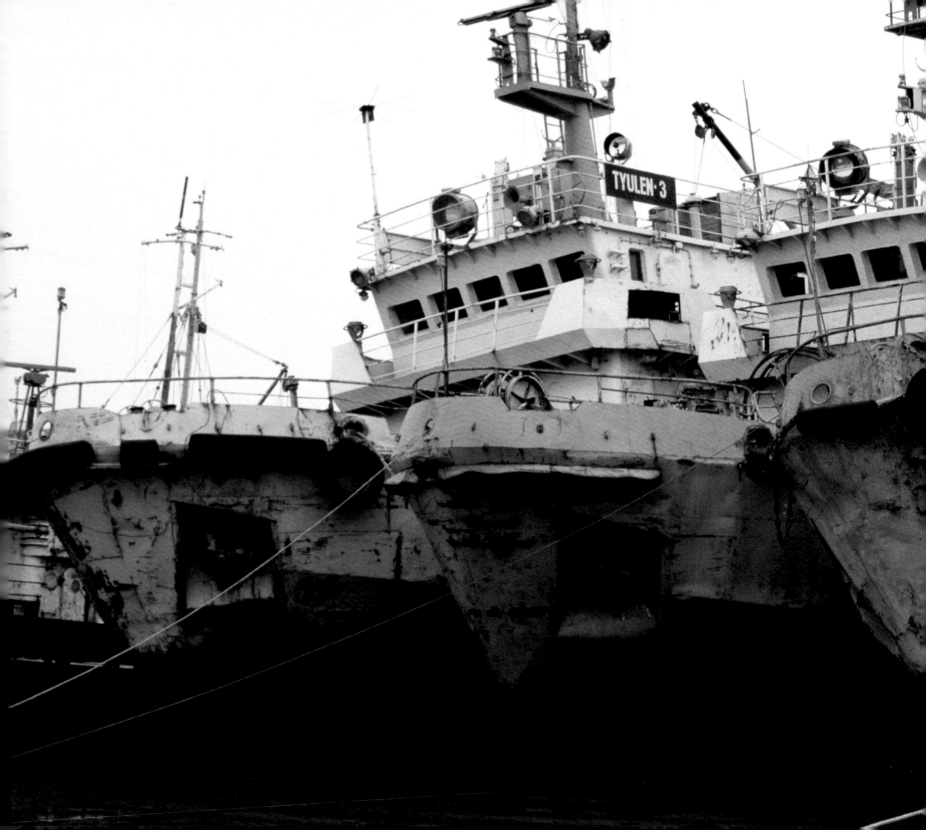

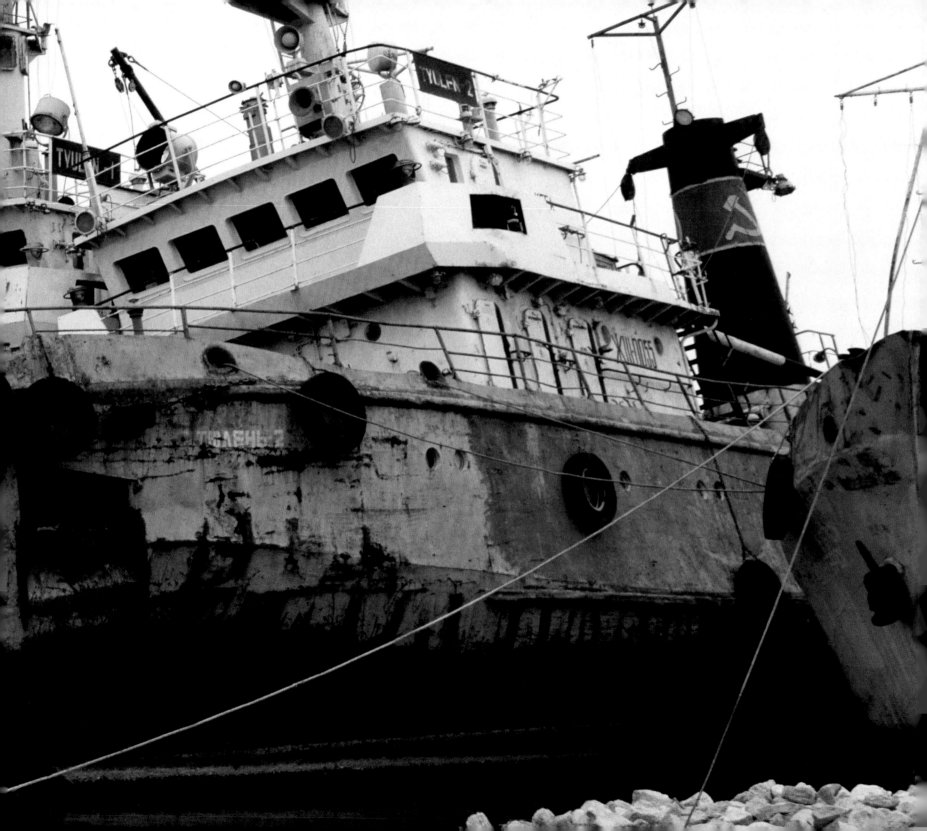

The Yellow Hats
Mongolia

For centuries Buddhism has been the traditional religion of Mongolians, who follow the Gelug school of Tibetan Buddhism, commonly called the Yellow Hats. Seen here in the elaborate crescent-shaped hats worn during ceremonies, the Yellow Hats are known for their rigid rules on learning, restraint and celibacy.

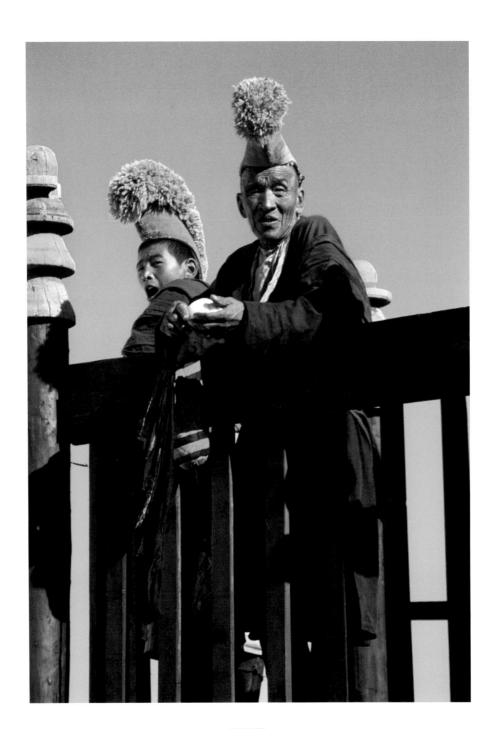

Relics in a Buddhist monastery
Ulaanbaatar
Mongolia

Figures symbolising life and death line the walls of the Choijin Lama Temple, a Buddhist monastery in the Mongolian capital, Ulaanbaatar. Lamaseries were viciously suppressed by the Soviets, who slaughtered thousands of monks. A few remained in hiding, burying their sacred texts, and were able to revive the religion in the early 1990s shortly before they died.

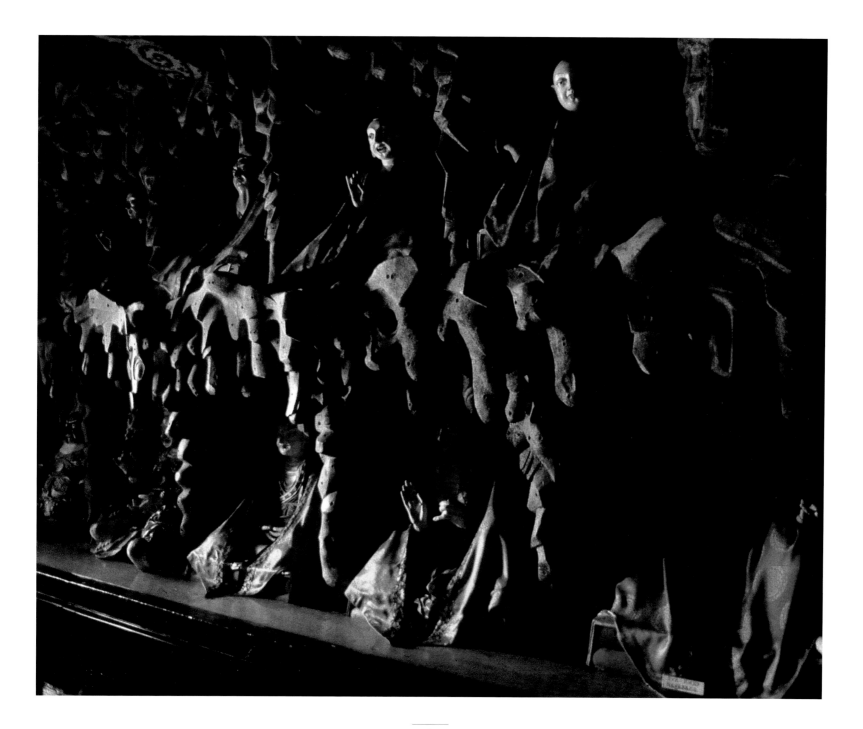

A mala for meditation
Ulaanbaatar
Mongolia

A monk moves his *mala* through his fingers at the Gandan Monastery in the Mongolian capital. Traditionally, these prayer beads are used during meditation to count the number of mantras recited or breaths taken.

Ulaanbaatar evolved out of a yurt city founded by nomadic Buddhist monks in the 17th century. Known as the Great Camp (*Ikh Khüree*), it moved 28 times before coming to rest permanently in Urga on the banks of the sacred Tuul River in 1778, where it remains to this day. Surrounded by four revered mountains, the Great Camp rivalled Lhasa for artistic splendour.

Ulaanbaatar gained its name, meaning Red Hero, from Sukhbaatar, who liberated Outer Mongolia from Chinese rule in 1921 with Soviet help.

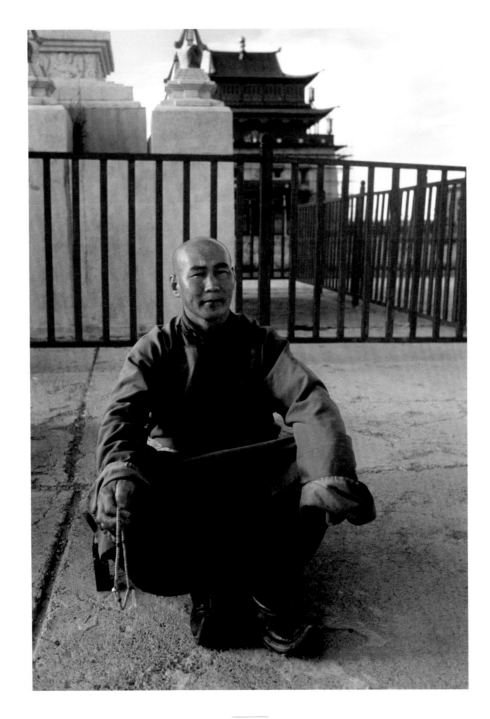

Candidates for monkhood
Karakorum
Mongolia

A group of young novice monks sit on the steps of the Laviran Temple, part of the enormous 16th-century Monastery of Erdene Zuu (Hundred Treasures) in the Orkhon Valley.

More than a hundred *stupas* top the walls surrounding this complex. Nearby are the ruins of ancient Karakorum, once the capital of the Mongol Empire.

The Orkhon Valley was the seat of Turkic steppe empires long before Genghis Khan and the Mongols set up their capital there. Turkic lore venerated the valley and the nearby mythical mountain-forest of Ötüken, source of *kut*. This was the vitalising force from the sky that rulers believed gave them the divine right to rule.

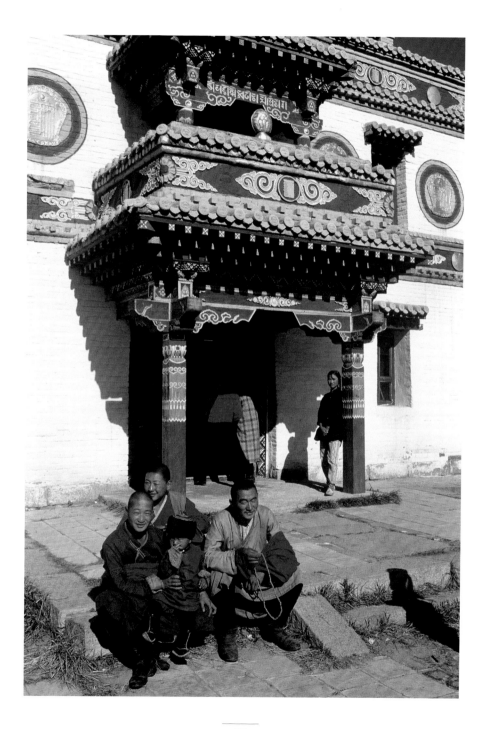

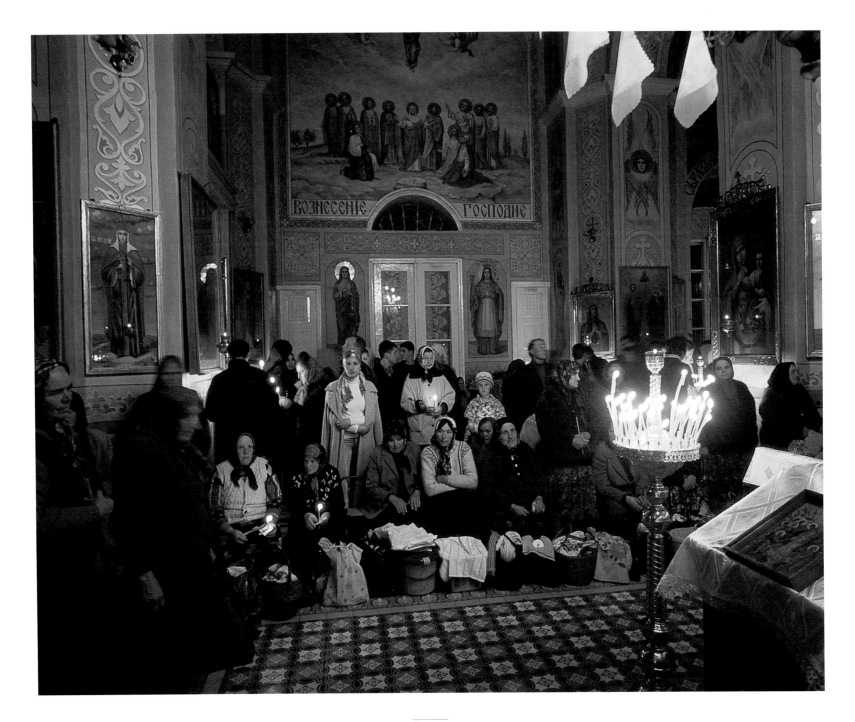

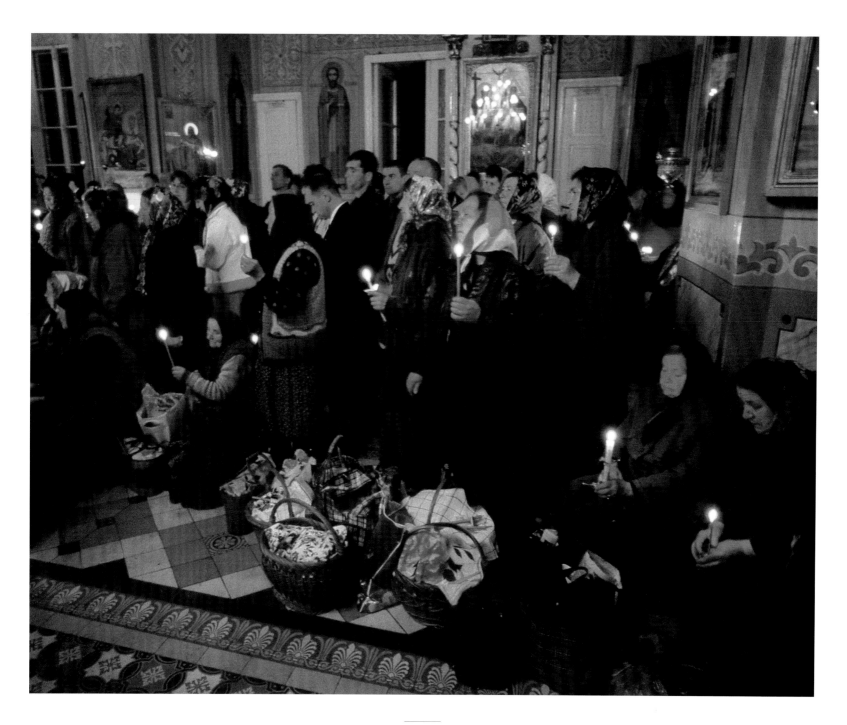

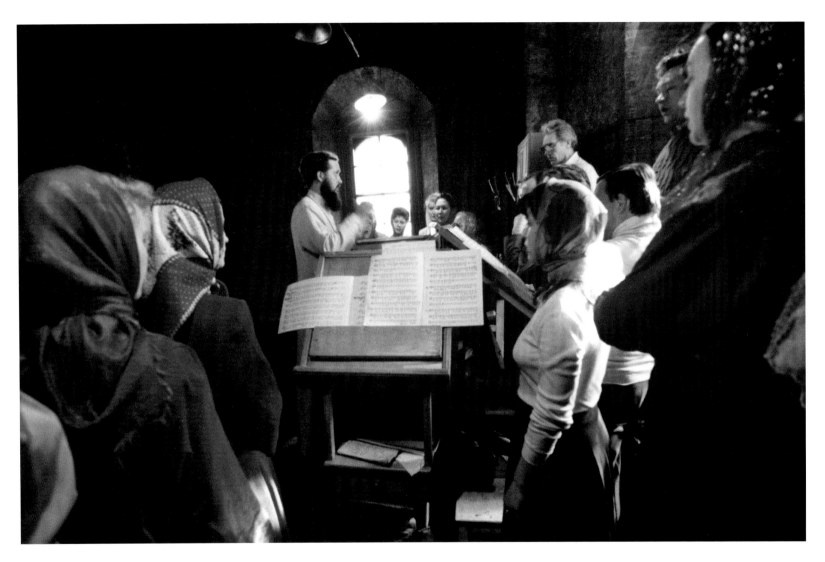

Previous pages
Easter in Gagauzia
Comrat
Moldova

At half past three on Easter morning in the Cathedral of St John the Baptist in Comrat, capital of Gagauzia, parishioners wait for the priest to arrive to bless the food they have prepared. The Gagauz, a small

Turkish-speaking Russian Orthodox group of fewer than 200,000, have their own autonomous region in the northwest corner of the Black Sea, historically a province of the Crimean Khanate, now part of Moldova.

Their origins are the subject of fierce debate. Their name does not appear in the records before the 19th century.

What we know is that Turkish-speaking Christians were living in the Ottoman Balkans

at the end of the 18th century, especially in parts of Bulgaria and Romania. After the 1806–12 Russo–Turkish War, they were resettled in Southern Bessarabia – today's Gagauzia – to replace Muslim Nogai Tatars

deported to the Ottoman Empire by Russia, an early exchange of populations.

Vineyards and wine have always been an important part of the Gagauz economy. Practically every house still has a wine cellar.

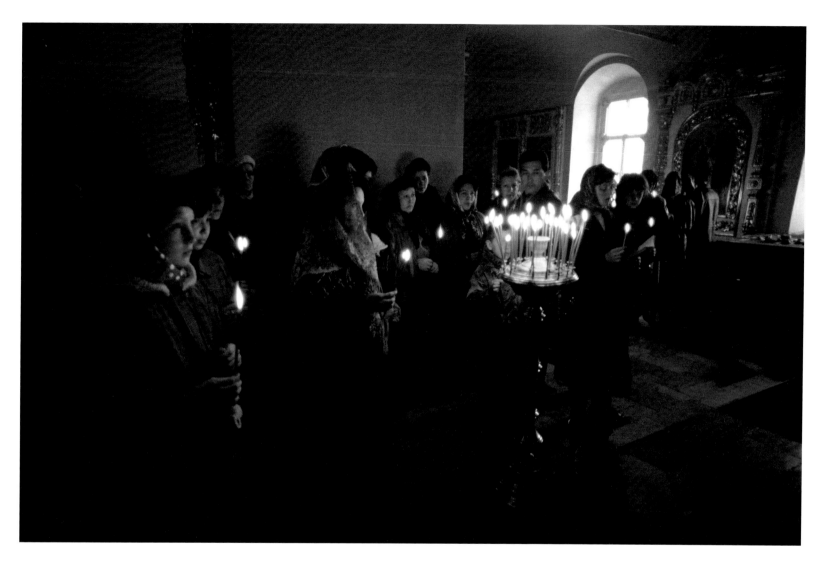

Opposite and above
Songs of praise
Cheboksary
Chuvashia, Russia

Chuvash singers rehearse in Vedensky Cathedral in Cheboksary, the capital of Chuvashia (opposite). Above: worshippers holding candles take part in an Easter service.

Russians founded the city of Cheboksary in the 16th century, and the Chuvash accepted Orthodox Christianity, although to this day some Chuvash villages retain their shamanist beliefs, most notably around the town of Bilyarsk, now in neighbouring Tatarstan.

Russification, however, was resisted when it came to language. Chuvash enjoyed revivals in the 18th and 19th centuries; the first grammar was published in 1769 and an alphabet created in 1871. Ilya Ulyanov, Lenin's father, pioneered the opening of Chuvash schools and urged his son to learn the language. After the fall of the Soviet Union in 1991, laws were enacted to protect the language, which is still spoken by some two million people.

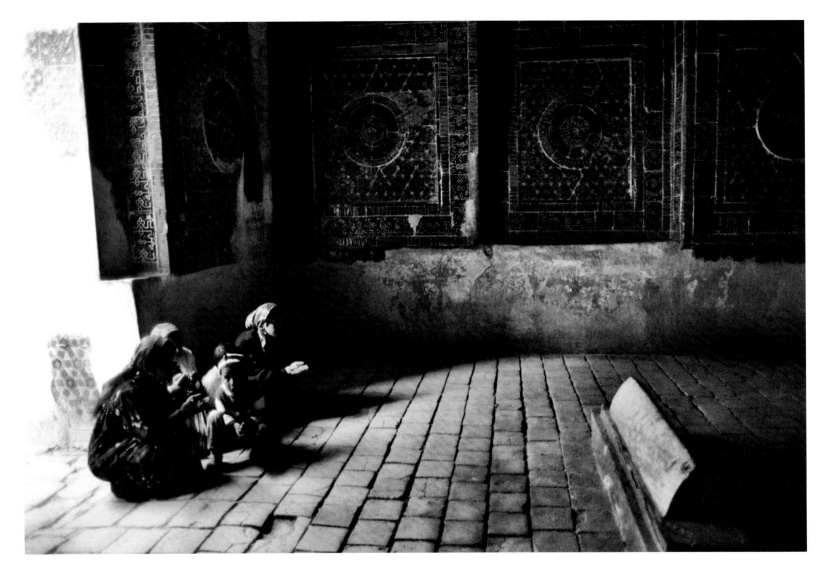

A venerated daughter
Samarkand
Uzbekistan

Pilgrims make the rounds of the Shah-i Zinda necropolis in Samarkand, stopping at the tomb built by Timur's sister for her daughter, Ulja Shad-i Mulk, who died in 1372. The mausoleum is noted for its tilework, both inside and out. In the corners (opposite), lavishly tiled honeycomb (*mukarnas*) half-domes rise between the shallow niches to support a central dome. Tiles were often gilded after firing. Çağatay captured the tomb in the 1990s, when it was at its most atmospheric.

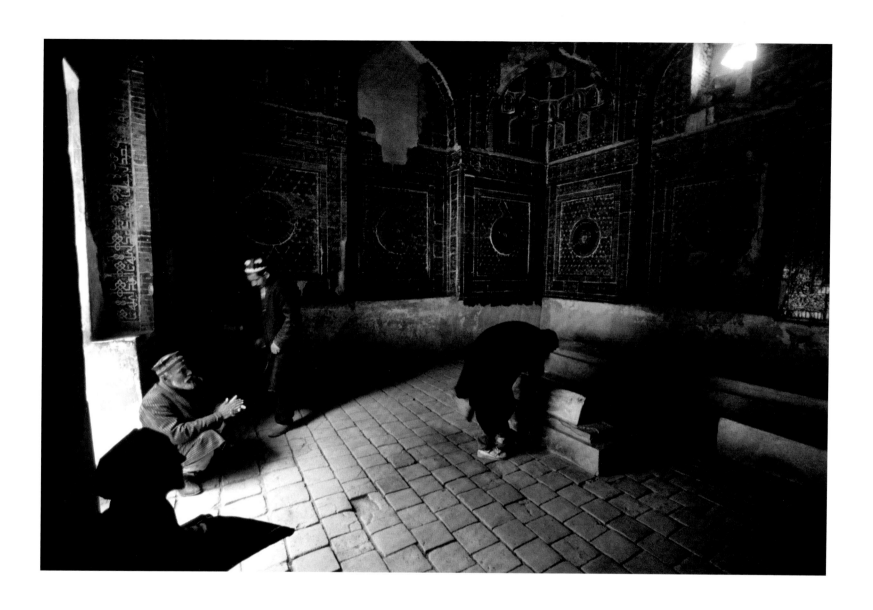

Golden discs
Uzbekistan

Throughout the Turkic heartlands, elderly men are held in high esteem and respectfully referred to as *aksakal* ('white beard'). This man is wearing a traditional stripy *chapan*. He is selling bread known to the Russians as *lepyoshka*. To Uzbeks and Tajiks it is simply '*non*' (the word is Persian, often transliterated as *naan*). Right across Central Asia these golden discs are served at every meal along with steaming cups of *chai*. Here, the bread is wrapped in *bohças*, squares of cloth tied by the corners.

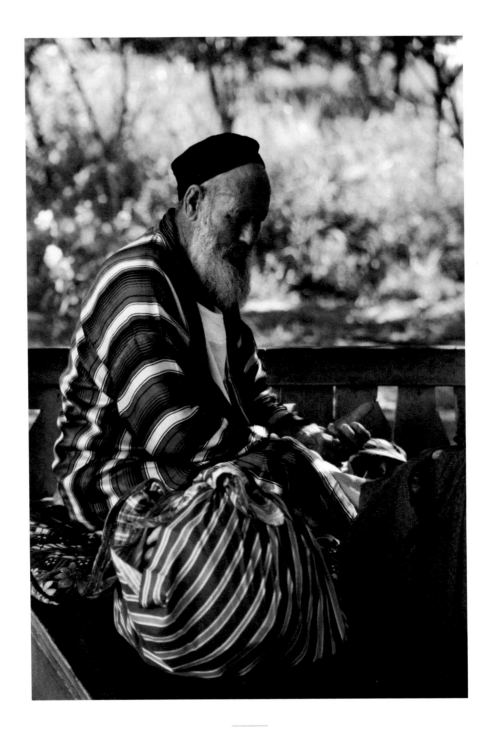

Woodcarvers of Khiva
Khiva
Uzbekistan

Carving a column from the local elm, *karagach* ('black tree'), sometimes known as Turkestan elm. This wood is popular for pillars and doors, as is walnut. Juniper is occasionally used, while mulberry tends to be favoured for musical instruments.

There are three main woodcarving styles in Uzbekistan: *bagdadi*, *islimi* and *parkâri*. The *bagdadi* style is the most common and incorporates simple geometric figures with no background. The *islimi* style has several layers, or backgrounds, and often features vines, flowers and leaves. The *parkâri* style (feather-work) is created by drawing sketches onto the wood, often with compasses, before carving.

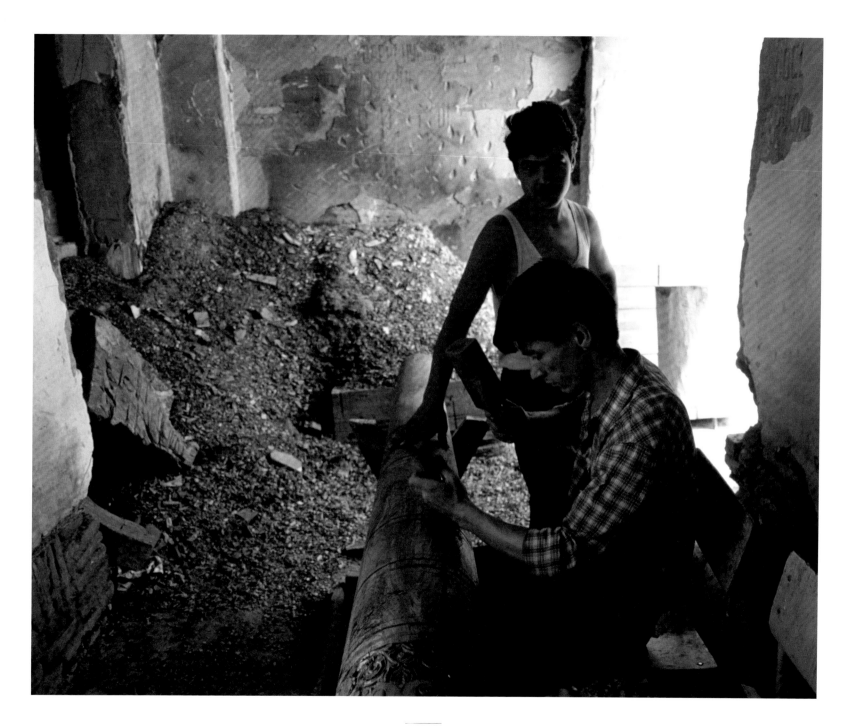

Potters of Rishtan
Uzbekistan

There are two main
centres of ceramic
production in Uzbekistan:
Rishtan in the Fergana
Valley and Gijduvon near
Bukhara. Some historians
claim Rishtan is the
oldest centre of ceramic
art in Central Asia. The
work there is identifiable
by its colours, usually
turquoise, dark blue
and brown on a cream
background, whereas
in Gijduvon ceramics
are characteristically
greenish-brown.

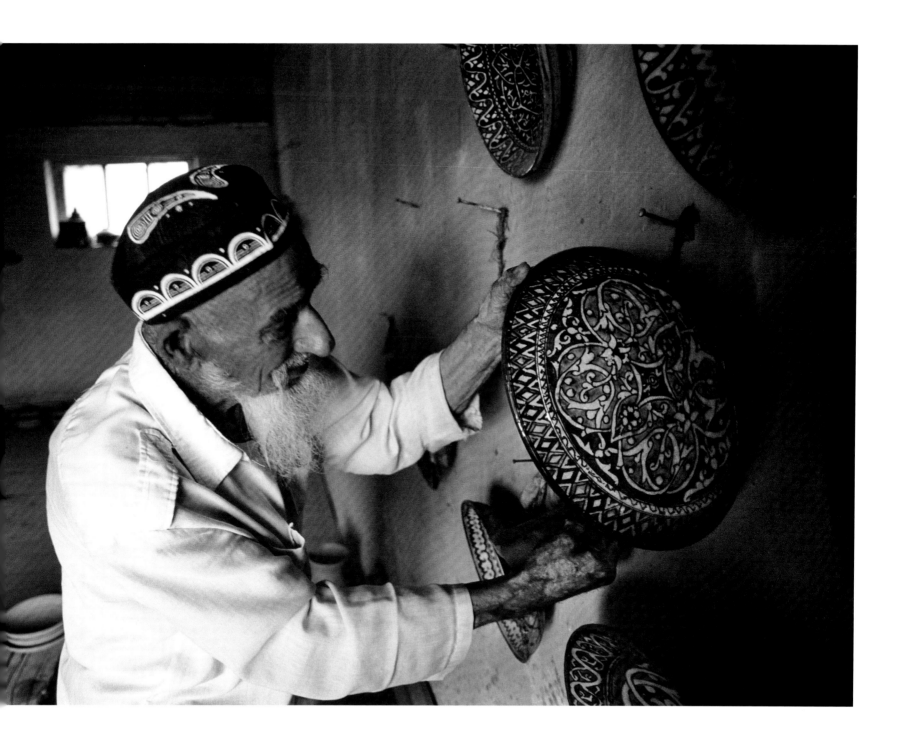

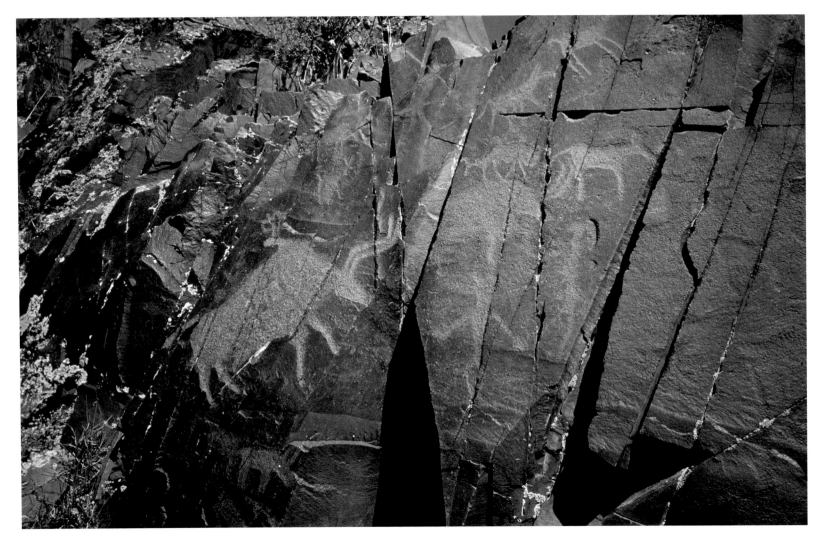

Bronze Age rock art
Tamgaly
Kazakhstan

Prehistoric petroglyphs provide a vivid record of life and climate change on the Eurasian steppe over more than five millennia – most famously in the Tamgaly valley, in a spur of the Tien Shan Mountains northwest of Almaty, and in the remote

Mangystau province in western Kazakhstan.

Around 5,000 figures can be seen at Tamgaly, a UNESCO World Heritage Site. Motifs dating from the Bronze Age capture the time when hunter-gatherers turned to animal

husbandry as a harsher, drier climate shrank forests to grassland and wild game died out. Carvings depict aurochs with long, curved horns and two-humped camels, hunting scenes with archers, solar-headed figures, groups of ritual

revellers and the sacrifice of horses – some wearing horns. (Horse sacrifice was widespread in Central Asia.)

Later, medieval petroglyphs show the mounted warriors and banners of the early Turkic khaganates from

the 6th to the 9th centuries. Nomadic Kazakhs continued the tradition of rock art into the 20th century, when Soviet five-pointed stars and portraits of Lenin joined the repertoire of hunters and *tamgas* (tribal emblems).

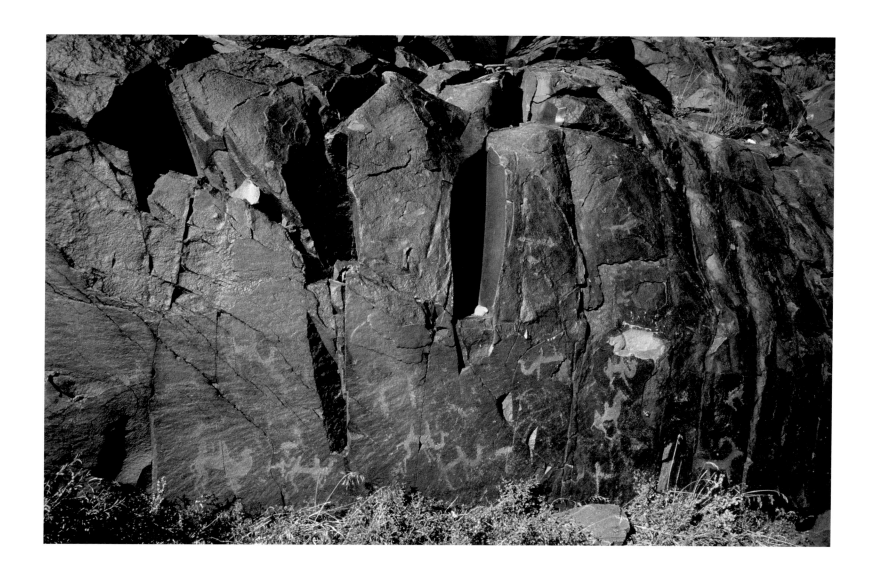

Castles in the sand
Khorezm
Uzbekistan

South of the Aral Sea are
the ancient fortresses
(*kalas*) of Uzbekistan's
Khorezm province, a
region traditionally
known as Ellik Kala (Fifty
Fortresses). Along with
ancient oasis settlements,
many of these colossal
castles in the Kyzylkum
(Red Sands) Desert date
back more than 2,000
years. This photograph
shows the ruins of Ayaz
Kala, a group of three
mud-walled citadels
built between the
4th century BC and the
7th century AD but only
discovered in the 1940s.

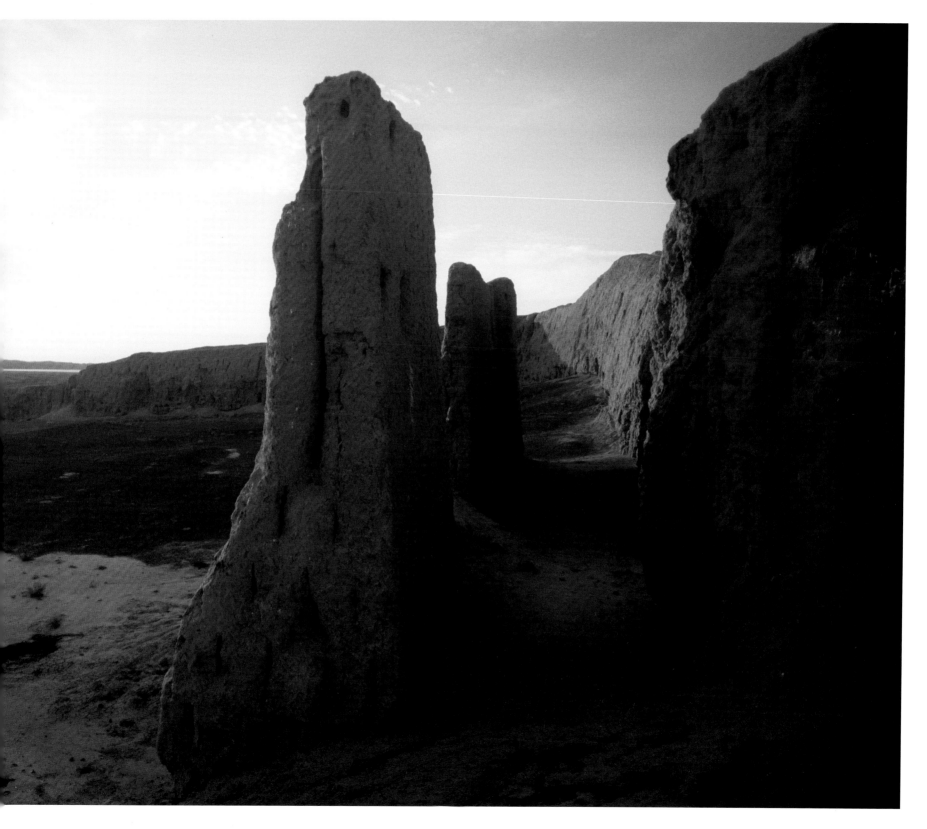

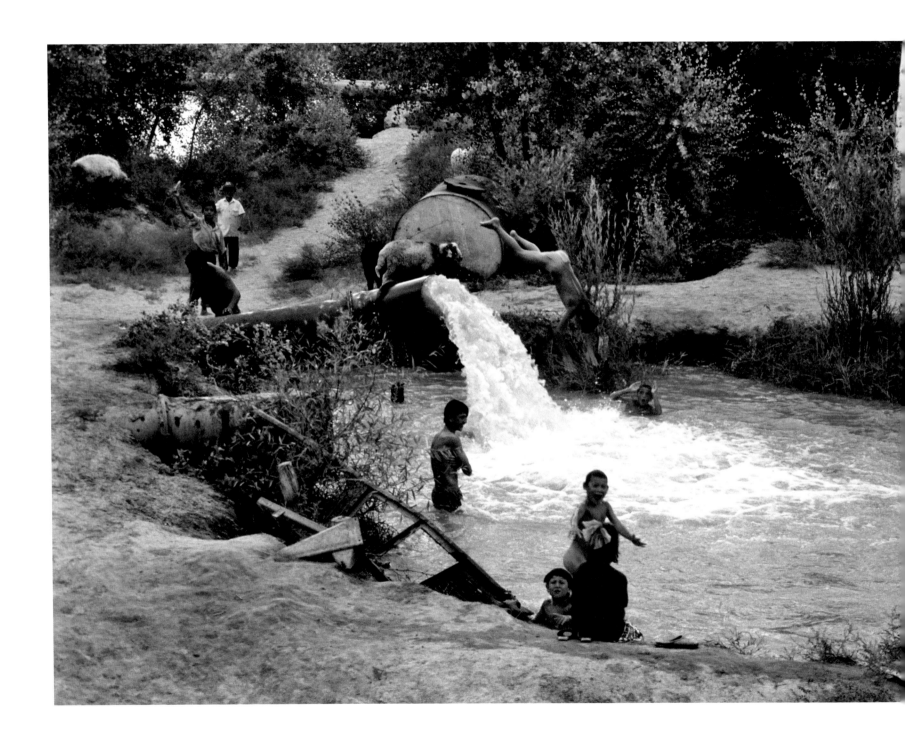

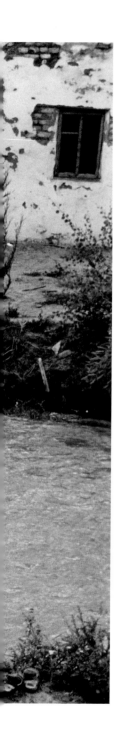

Fun in the wet gold
Uzbekistan

Water is 'wet gold' in Central Asia, as its supply is never straightforward. Dams, hydropower plants and water resources continually affect the delicate balance of power, politics and influence in the region.

Between the Amu Darya and the Syr Darya, the world's densest irrigation network has turned deserts into lively oases, but it is causing serious salinisation. Huge canals dug out in the 1940s have also led vast quantities of water to drain into the ground or to evaporate into the air.

The greatest, and most documented, victim of bad Soviet planning and diverted waters is, of course, the Aral Sea. So blighted is it still today that it also goes by a desert name, the 'Aralkum'.

Sunset at
the Father's Gate
Khiva
Uzbekistan

A child walks over
cobblestones through the
Ata Darvaza (Father's
Gate) in Ichan Kala,
Khiva's Inner City, in the
amber glow of a Central
Asian sunset. This was
the city's main gate,
demolished in 1920 and
rebuilt in 1975.

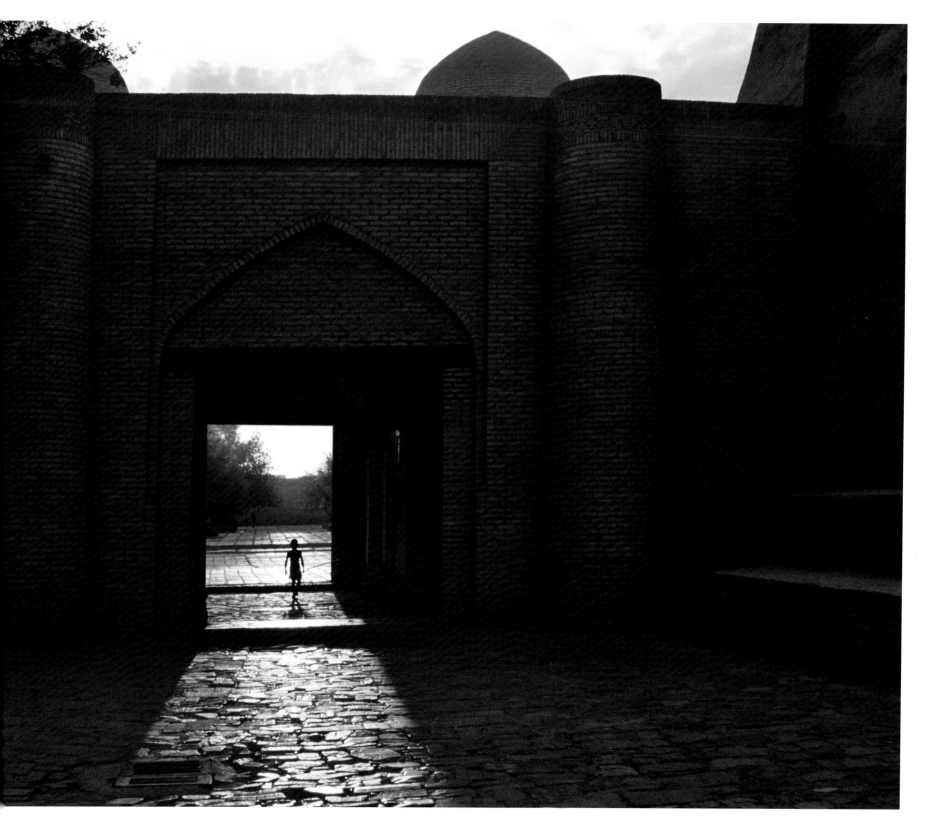

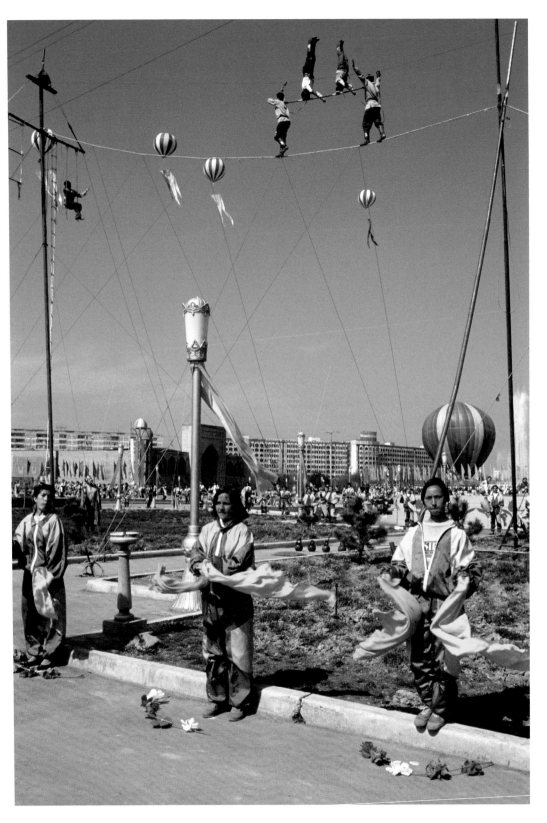

Left and opposite
The tightrope walkers
Tashkent
Uzbekistan

Banned for a period
during the Soviet era,
the spring equinox
celebration of Navruz
is now the biggest
Central Asian holiday.
Çağatay shows us
colourful celebrations in
Tashkent, behind the
Palace of Friendship.
Tightrope walkers
(*darbâz*) and acrobats,
here dressed in bright
colours and soft leather
boots, have long been a
popular feature of the
festivities. Usually, when
the *darbâz* reaches the
end of the rope, he will
go backwards, repeating
his stunts in reverse.

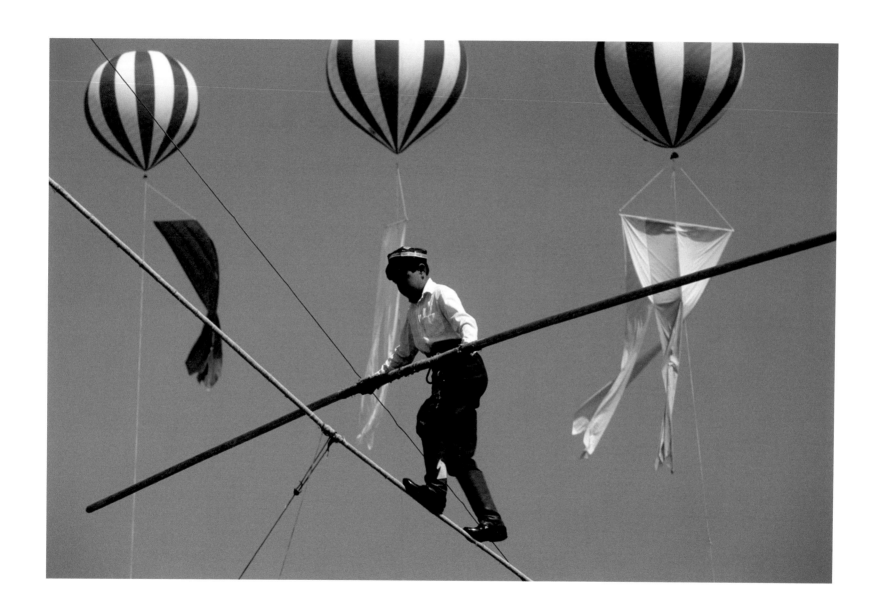

Baltic guardians
Trakai
Lithuania

Vytautas the Great, Grand Duke of Lithuania, brought the Karaim from Crimea to the shores of the Baltic six centuries ago to guard his castles on Lake Galvé against the Teutonic Knights. So appreciated was their loyalty that in 1441 they were granted self-governance.

Literally 'readers of The Book', the Karaim are a small Turkic-speaking group who practise an archaic form of Judaism that rejects the post-Biblical tradition of the Talmud. Part of the semi-nomadic Turkic Khazarian Empire that flourished in the lands north of the Caspian and the Black Sea, they adopted Karaism in the 9th century.

For centuries they owed allegiance to the Grand Dukes and latterly to the Kings of Poland, their *kenessah* thriving alongside a Tatar mosque, a Catholic church and a Uniate monastery. They were famed as scholars, artisans and gardeners, and still grow the best cucumbers, the *Karay hiyari*.

There is a sad sense of finality about the future of the Karaim, who have managed to preserve their identity within Lithuania so well for more than 600 years, but now number no more than a few hundred.

A Cornucopia Book
Published in 2020 by
Caique Publishing Ltd,
1 Rutland Square,
Edinburgh EH3 3AY, in
association with Kayık
Yayıncılık Ltd, Valikonağı
Caddesi 64, Nişantaşı,
34367 Istanbul

isbn 978-0-9957566-2-5
isbn 978-605-62429-1-5

Text © Caroline Eden 2020
Photographs © the heirs of
Ergun Çağatay

Project editors
John Scott, Berrin Torolsan
Design Clive Crook
Text editors Susana Raby, Tony Barrell,
Hilary Stafford-Clark, Rose Shepherd
Map Susanna Hickling

Printed and bound in Turkey
by Ofset Yapımevi, Istanbul
www.ofset.com

Cornucopia Books
PO Box 13311,
Hawick TD9 7YF, Scotland
www.cornucopia.net/ankabird

Acknowledgements

**The publishers are indebted
to the late Ergun Çağatay's wife,
Kari Wulff Çağatay, their son,
Erol Çağatay, and their daughter,
Yasemin Oytaç, for kind permission
to publish his photographs.**

Ergun Çağatay's archivists Seval
Alpaslan and Semra Aslan Yücel
provided invaluable assistance in
retrieving the images used. The original
selection was made by Berrin Torolsan
with Ergun Çağatay in 2009.
 Numerous experts generously shared
valuable insights: Dr Yorgos Dedes of
SOAS, London, on language; Anthony
Fitzherbert on pastoral culture and
yurts; Dr Tereza Hejzlarová of Palacký
University, Olomouc, on costume and
beliefs; Jérôme Magail of the Museum
of Prehistoric Anthropology of
Monaco on Mongolian 'deer stones'; and
Tim Stanley of the Victoria and Albert
Museum on tilework
 Thanks go to the historian
Prof Dr Hasan Ali Karasar, Rector of
Cappadocia University, and the author
Antony Wynn, who has travelled widely
in the region, for guidance on the
manuscripts, and to the novelist
Hamid Ismailov for sharing the saying
about the Homâ Bird on page 14.

The author: Caroline Eden

Caroline Eden contributes to the travel,
food and arts pages of the *Guardian*, the
Financial Times and the *Times Literary
Supplement*. She has recorded stories
from Kyrgyzstan, Kazakhstan, Uzbekistan,
Azerbaijan and Russia for BBC Radio 4's
From Our Own Correspondent. She is
the author of three books, *Samarkand*
(Kyle Books, 2016), *Black Sea* (Quadrille,
2018) and *Red Sands* (Quadrille, 2020).
Twitter and Instagram: @edentravels.

Bibliography

General non-fiction: history and travel literature

Burnes, Alexander. *Travels into Bokhara: A voyage up the Indus to Lahore and a journey to Cabool, Tartary and Persia in the years 1831–33* (Eland, 2012)

Boulnois, Luce. *Silk Road: Monks, Warriors & Merchants* (Odyssey, 2004)

Curzon, George. *Russia in Central Asia in 1889: And the Anglo-Russian Question* (Cass, 1967)

Frankopan, Peter. *The Silk Roads: A New History of the World* (Bloomsbury, 2015)

Hansen, Valerie. *The Silk Road: A New History* (Oxford University Press, 2012)

Hare, John. *Mysteries of the Gobi: Searching for Wild Camels and Lost Cities in the Heart of Asia* (IB Tauris, 2009)

Hopkirk, Peter. *The Great Game: On Secret Service in High Asia* (John Murray, reprint 2006)

Lillis, Joanna. *Dark Shadows: Inside the Secret World of Kazakhstan* (IB Tauris, 2018)

Robbins, Christopher. *In Search of Kazakhstan: The Land That Disappeared* (Atlas, 2008)

Hopkirk, Kathleen. *Central Asia Through Writers' Eyes* (Eland, 2014)

Maillart, Ella. *Turkestan Solo: A Journey Through Central Asia* (Tauris Parke Paperbacks, 2005)

Man, John. *Gobi: Tracking the Desert* (Yale University Press, 1999)

Metcalfe, Daniel. *Out of Steppe: The Lost Peoples of Centra Asia* (Hutchinson, 2009)

Moorhouse, Geoffrey. *Apples in the Snow: A Journey to Samarkand* (Hodder & Stoughton, 1990)

Thubron, Colin. *The Lost Heart of Asia* (Heinemann, 1994)

Whittell, Giles. *Extreme Continental: Blowing Hot and Cold Through Central Asia* (Orion, 1995)

Whitlock, Monica. *Beyond the Oxus: The Central Asians* (John Murray, 2003)

Illustrated books

Antipina, Claudia. *Kyrgyzstan* (Skira, 2007)

Baumer, Christoph. *The History of Central Asia*: 4 vols (IB Tauris, 2018)

Çağatay, Ergun, **Kurban**, Doğan eds. *The Turkic Speaking Peoples: 2,000 Years of Art and Culture from Inner Asia to the Balkans* (Prestel, 2006)

Gardner, Başak, **Gardner**, Christopher. *Flora of the Silk Road: An Illustrated Guide* (Bloomsbury, 2019)

Eden, Caroline. *Samarkand: Recipes and Stories from Central Asia and the Caucasus* (Kyle Books, 2016); *Red Sands: Reportage and Recipes through Central Asia, from Hinterland to Heartland* (Quadrille, 2020)

Harvey, Janet. *Traditional Textiles of Central Asia* (Thames & Hudson, 1997)

Janabayeva, Galiya Dabylovna. *Arts of the Peoples of Central Asia* (Central Asian Program, George Washington University, 2019)

Knobloch, Edgar. *Monuments of Central Asia: A Guide to the Archaeology, Art and Architecture of Turkestan* (IB Tauris, 2001)

McClary, Richard P. *Medieval Monuments of Central Asia: Qarakhanid Architecture of the 11th and 12th Centuries* (Edinburgh University Press, 2020)

Maclean, Fitzroy. *To the Back of Beyond: Illustrated Companion to Central Asia and Mongolia* (Jonathan Cape, 1974)

Meller, Susan. *Russian Textiles: Printed Cloth for the Bazaars of Central Asia* (Henry N. Abrams, 2007)

Morton, Margaret. *Cities of the Dead: The Ancestral Cemeteries of Kyrgyzstan* (University of Washington Press, 2014)

Omrani, Bijan. *Asia Overland: Tales of Travel on the Trans-Siberian & Silk Road* (Odyssey Guides, 2010)

Whitfield, Susan. *Silk Roads: Peoples, Cultures, Landscapes* (University of California Press, 2019)

Books by Ergun Çağatay

Bir Zamanlar Orta Asya / Once Upon a Time in Central Asia (Tetragon, 1996).

The Turkic Speaking Peoples: 2,000 Years of Art and Culture from Inner Asia to the Balkans (Prestel with the Prince Claus Fund Library, 2006). Turkish edition: *Türkçe Konuşanlar: Orta Asya'dan Balkanlar'a 2000 Yıllık Sanat ve Kültür* (Otokar, 2007).

Ergun Çağatay (Photographers Series 9) ed. Melih Akoğul (Eczacıbaşı Foundation, 2018).

Index

Let the trumpets sound
Uzbekistan

The thrilling rhythmic sound of the *karnay*, a brass trumpet two metres long, once urged Timur's armies into battle. Today 'the bellowing of the dinosaurs', as it is often described, announces festivities, such as Navruz, Independence Day and weddings. *Karnays* are often accompanied by *surnays*, traditional two-reed clarinets, *doira* frame drums and *nog'ora* kettledrums. The *karnay* is treated with reverence. Held skywards, it is said to be speaking directly to God.

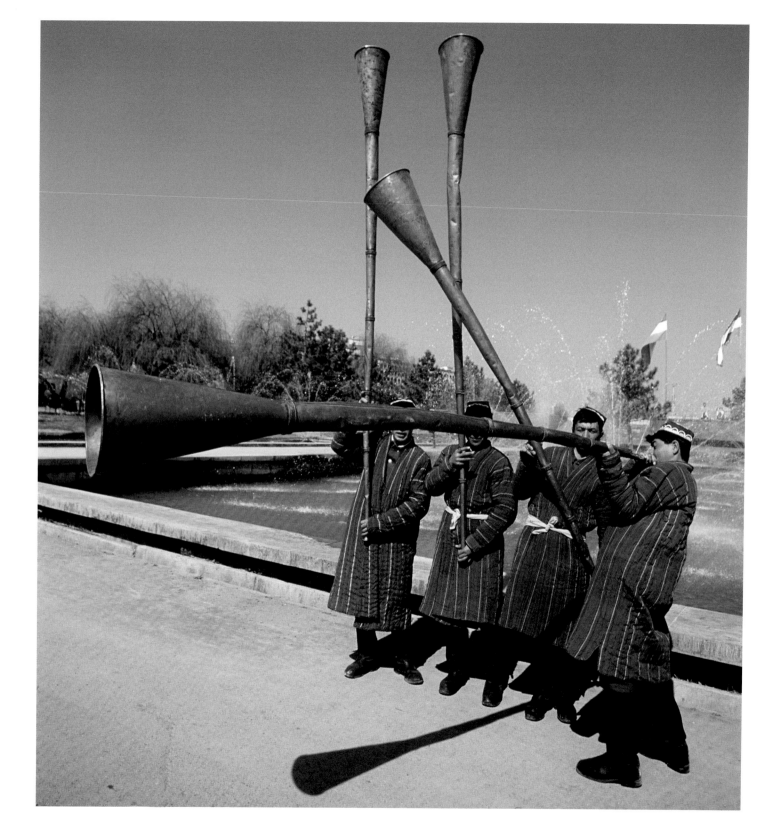